Preserving Old Barns
Preventing the Loss of a Valuable Resource

John C. Porter
Proverbs 3: 9-10a

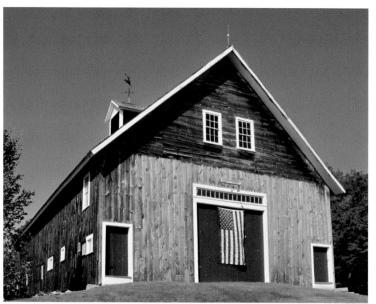

A Barn for All Seasons

The Elm Farm Barn on the old Pettee Homestead on Route 136 (New Boston Road) in Francestown is a landmark enjoyed by everyone who drives by. It is the barn for all seasons, as the Careys put a decoration on the front door appropriate for the time of year—spring and summer are represented by the flag; fall by an autumn wreath; and winter by a Christmas wreath. (Top two photographs by Lowell Fewster. Bottom photograph by Jim Salge.)

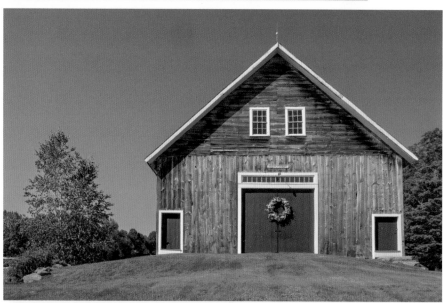

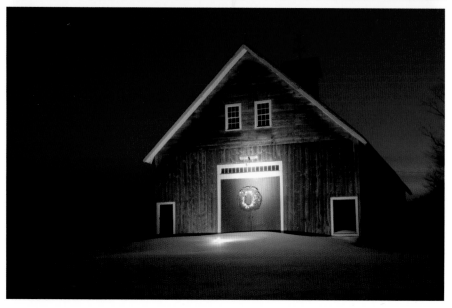

Preserving Old Barns
Preventing the Loss of a Valuable Resource

JOHN C. PORTER
Extension Professor/Specialist, Emeritus
UNH Cooperative Extension

FRANCIS E. GILMAN
Extension Agricultural Engineer, Emeritus
UNH Cooperative Extension

with photography by
LOWELL H. FEWSTER

Published by
PETER E. RANDALL PUBLISHER
Portsmouth, New Hampshire
2019

First edition 2001
Second edition 2019

ISBN: 978-1-942155-24-9
Library of Congress Control Number: 2019938417

Unless otherwise noted, photographs are by John C. Porter.

Cover photographs: Lowell Fewster

Published by
Peter E. Randall Publisher
Box 4726
Portsmouth, NH 03802
www.perpublisher.com

Book design by Grace Peirce

Dedication

The New Hampshire "Barn Committee" dedicates this book to the life and memory of Francis E. Gilman. Francis was a co-author of both editions of *Preserving Old Barns* and added his wisdom and engineering expertise to their content. Francis was an agricultural engineer for the University of New Hampshire Cooperative Extension from 1969 until his retirement in 1990. He passed away July 24, 2018, just a week before his ninety-second birthday and prior to the printing of this book.

Francis was known for his knowledge of both old and new barns and was a valuable resource to the New Hampshire "Barn Committee." He gave barn talks to historical groups, served as a consultant to check barn grant restoration projects, and was a frequent participant on the summer barn tours. Francis was respected as a barn guru throughout the northeast region and was known for his practical advice and common-sense approach to solving structural problems. He did a lot to educate his younger co-workers about farm buildings and enjoyed emphasizing the definition of concrete. Whenever someone asked if a structure needed a "cement" floor, Francis would say, "That would be too dusty, I would recommend concrete," referring to the fact that cement is just an ingredient in concrete. Those of us who worked with him never forgot that.

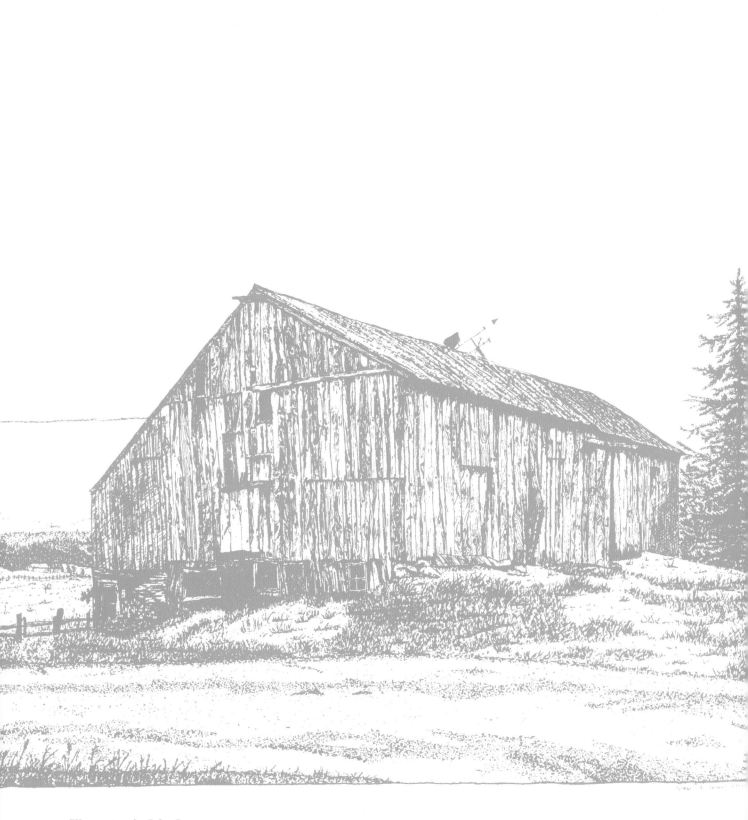

Illustration by John Lamoureux

Not for Sale

It stands in tribute to an era gone by
This old barn, this sore to the eye.
And atop this time-ravaged citadel
Points a weather vane;
Its rusty cow half gone, its arrow askew;
A portrait of relentless seasonal pain.
In the background, with little or nothing to do,
Are uncut fields of hay and ungrazed pasture land.
The barbed-wire fences, once yearly mended,
Now droop from posts that only randomly stand.
Who is guilty of this scene unattended?
What happened to the heirs of the Estate?
Was it the lure of other professions,
Or perhaps some obligation that couldn't wait?
And you doctors or lawyers, or who-ever,
With all of your accumulated fees,
Do you think you can "own" these maple trees?
I can remember when they were tapped and anxious to run!
When they didn't believe in drawing unemployment from the sun,
Or simply providing shadows
For the spirits of the once proud owners that now silently cry!
O your name may be on the deed,
The title may even be right in your hand,
But until you till the soil, pick the stone and sow the seed,
Until you work this mixture of sod, silt and sand,
Your attempts to be one of them will fail
You see sir, the soul of this farm . . .
Is not for sale!

*By Paul A. Mason (son of the previous farmer and owner of the barn shown
on the adjacent page, and a former neighbor of John Porter in Lebanon).*

Poet's note: This reflection was an attempt to deal with some of the
dynamics of life. It was the end of a chapter, an era gone by. I wanted
to hold onto those days, and in some way, keep that which could not be
mine. It is a tribute to those who labored so hard by hand and heart. At
the same time, it is a challenge to those with title in hand to become
ingrained in their land and buildings, for only then can final ownership
be consummated, only then will the stewardship of care give peace to the
spirits of yesteryear.

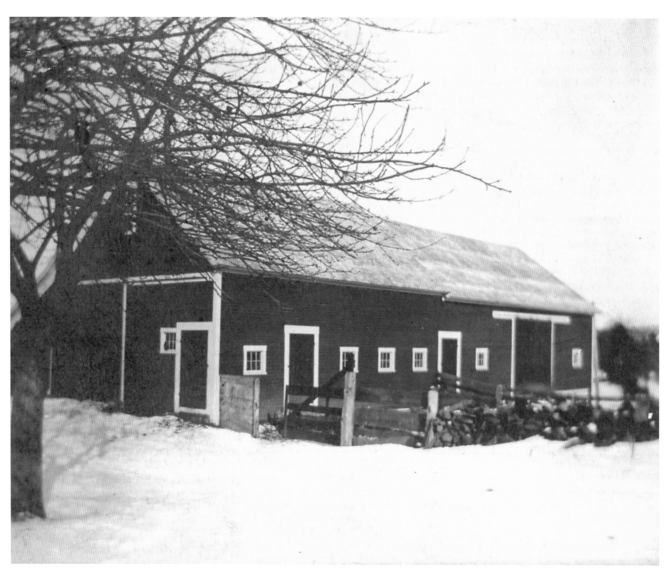

John Porter has a heritage in old barn preservation. This barn was on the Porter Homestead in North Plainfield. Reverend Micaiah Porter moved to River Road in lower Plainfield in 1804 from Voluntown, Connecticut, and then to the farm on Black Hill in 1805. There were a house and barns on the property. The original house burned in 1840, and his son, Jabez, built the present farmhouse. In 1905, Micaiah's grandson, John Porter, moved a Yankee barn across the yard and within twelve feet of the end of an existing English barn. The two were connected, and John Porter clapboarded and painted them. The addition allowed them to expand their farming operation. The Porter family lived on the homestead until 1960, but the author's father, Clifton Porter, moved off the farm and started his own dairy farm in Lebanon in 1949. Now Micaiah's great-great-great-grandson, John Porter, is writing about barn preservation.

Contents

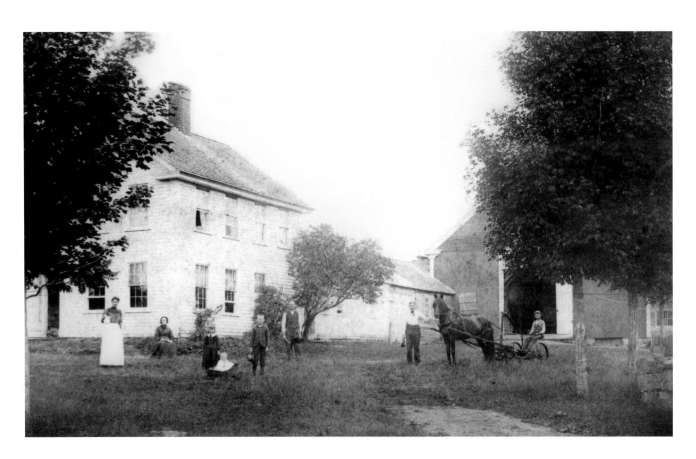

Whittier Farm, Deerfield, circa 1890.
(Photograph courtesy of Sue Porter.)

Acknowledgments

New Hampshire Historic Agricultural Structures Preservation Initiative

This publication is part of a statewide, collaborative initiative to preserve old agricultural buildings and was developed to meet the high demand from barn owners and advocates for advice to help reverse the trend of barn loss across New Hampshire. This effort is led by the New Hampshire Historic Agricultural Structures Advisory Committee (also known as the "Barn Committee"), which supported publication of this book, and by the New Hampshire Division of Historical Resources, the New Hampshire Preservation Alliance, and other partners in agriculture, conservation, and economic development.

Additional thanks are extended to the Barn Committee's Book Subcommittee members, who actively participated in the fundraising and editing to produce the second edition. They include Stephen Bedard, Erica Gish, Jennifer Goodman, Nathan Merrill, Elizabeth H. Muzzey, Pat Meyers, Carl Schmidt, and Beverly Thomas. Also, thanks to Arron Sturgis, of Preservation Timber Framing, Inc., of Berwick Maine, who joined the effort and added extensively to the chapter on barn preservation.

The Barn Committee's mission, as outlined in NH RSA 227-C:27, is to help prevent the unnecessary loss of old barns and other agricultural outbuildings that are so much a part of New Hampshire's history and landscape. An early objective of the Committee was to publish a book to serve as a resource for those wishing to preserve and maintain these old buildings. The popular first edition, published in 2001, has been reprinted two times. This revised 2019 edition expands the information offered and includes topics people have been asking about during barn talks and tours over the last twenty years.

Photography

The photography in the main text of the book was done by John Porter, unless otherwise noted, along with photographs labeled from Lowell Fewster. Beverly Thomas, of the New Hampshire Preservation Alliance, contributed several images to the section on barn features. Nathan Merrill, a member of the New Hampshire Historic Agricultural Structures Advisory Committee and the Stratham Heritage

Commission, and Cristina Ashjian, of the Moultonborough Heritage Commission, both provided substantial assistance in supplying photographs, obtaining release forms from barn owners, and editing. Also, Kate Crichton, publishing assistant with Peter E. Randall Publisher, contributed some photos, along with Jim Salge, Ed Pape, Jessica Matras, Joe Drapeau, Dottie Bean, Peter Rhoades, Scott Gardner, Jessica MilNeil, and Sue Porter.

Artwork

The pen and ink drawings in the book were done and donated by Martha Kierstead, unless otherwise noted. Martha has long been involved with New Hampshire agriculture.

The new drawings on joinery added to this edition of the book were produced by Jessica MilNeil, a carpenter with Preservation Timber Framing, Inc. in Berwick, Maine.

Graphics and Design

The first edition of the book was facilitated by Holly Young, who was Educational Marketing and Information Coordinator for UNH Cooperative Extension. Karen Holman, a graphic designer, did the initial layout. The second edition was coordinated by Deidre Randall and designed by Grace Peirce from Peter E. Randall Publisher in Portsmouth, New Hampshire.

Special Thanks

A special thanks goes to all the New Hampshire barn owners who agreed to have photographs of their barns included in this book. Also, to Paul Mason for use of his poem on the introduction page, and to John Lamoureux, who drew the accompanying sketch of the barn. Jon Vara gave permission for use of the article he wrote for the *Country Journal* about barn renovation. Several of his concepts were the basis of the pen and ink drawings used in this text. Tom Visser was very helpful in supplying information, and his book, *A Field Guide to New England Barns and Farm Buildings*, was a tremendous resource.

The author also wants to thank his wife, Sue Porter, for her patience and understanding through the long process of writing and editing this second edition of the book.

Financial Support

Development of the first edition was made possible with underwriting from The Mosaic Fund, The Samuel P. Pardoe Foundation, and other donors, through the New Hampshire Preservation Alliance. The publication was also financed in part with federal funds from the National Park Service, U.S. Department of the Interior, through the New Hampshire Division of Historical Resources / State Historic Preservation Office; and support from UNH Cooperative Extension in the development and publication of the book.

The second edition of the book was supported by the Conservation and Heritage License Plate Program (Moose Plate) at the New Hampshire Department of Natural and Cultural Resources, the Merciful Restoration Fund at the New Hampshire Division of Historical Resources, the New Hampshire State Grange, the Moultonborough Heritage Commission and the Stratham Heritage Commission. Individual supporters include Colin and Paula Cabot, Joe and Maggie Moore, Rebecca Mitchell, Carl Schmidt, and especially Elizabeth H. Muzzey, who devoted much time to working out the financial support and contractual arrangements. Several of these donors made their gifts in honor of John Porter, and strong interest in helping to save more old barns. Generous investments over time from Colin and Paula Cabot, Jane and Peter McLaughlin, and the N.H. Charitable Foundation, as well as tremendous commitments from tradespeople and hundreds of barn owners and advocates around the state have made it possible for the New Hampshire Preservation Alliance to help meet its goals for barn preservation and education, and projects like this book.

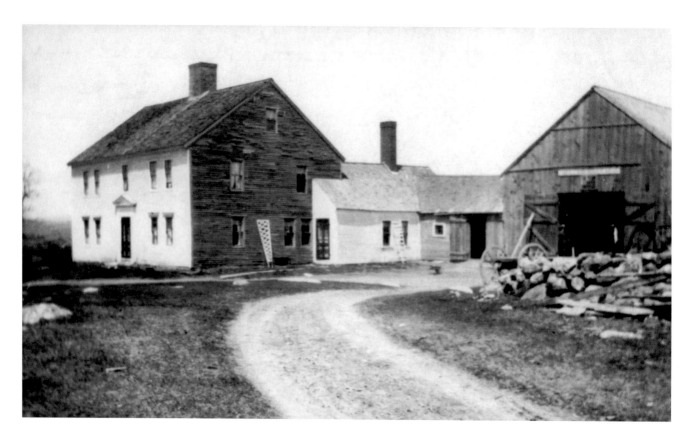

Fife Farm, Deerfield, circa late 1800s.
(Photograph courtesy of Sue Porter.)

Introduction

Today's rapidly advancing changes in technology bring constant updating and replacement of the equipment and buildings used in agriculture. Old barns are being abandoned to make way for structures that are better adapted to today's methods. While old barns are not always regarded as commercially functional, there is increased interest in preserving these venerable structures. Their unique architecture plays a crucial part in defining the scenic landscape and character of New Hampshire. Old barns embody much of the history of agriculture and society as it has evolved from colonial times.

Interest in barn preservation involves an appreciation of the beauty and history that agricultural structures contribute to the countryside. Many of New England's characteristic vistas are created by historic farmsteads nestled by the wayside with majestic, weathered barns, symbolic of days gone by. Along with various outbuildings, barns were historically essential parts of the farm unit in meeting the needs of rural

Dilapidated barns are a common sight around the rural countryside. Obsolescence, high maintenance costs, or lack of care have caused many of these historic structures to fall into disrepair. Each passing winter takes its toll on these structures until they may eventually collapse.

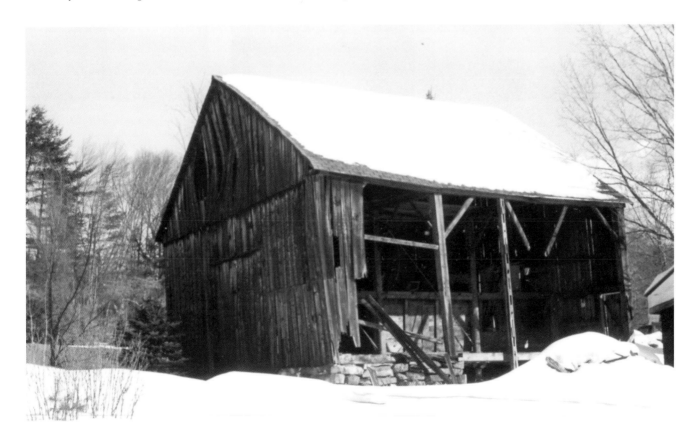

life. Preservation requires the owner to appreciate the aesthetic and historical value of the barn and to make a commitment to maintain its structural integrity.

Beyond aesthetics and a respect for history, economic incentives can help justify an investment in saving and preserving old barns. Some old barns are being torn down, when a little creative thinking could have given them new and productive uses. Education in barn preservation is intended to increase an appreciation for old barns as precious resources and to encourage people to consider basic preservation techniques rather than thoughtlessly demolishing irreplaceable features of our heritage. Economic incentives for preservation exist in the form of planning grants and tax relief.

A barn rehabilitation plan may involve having a vision of how the preserved structure might complement a business or serve productive new uses. Such uses might involve using the old barn for storage, retail sales, or auxiliary animal housing, thus retaining the atmosphere of the farmstead and producing an economic return.

Some people have the means or make the worthwhile financial sacrifice to fix up these old barns. This can involve replacing sills, adding a new roof, or installing siding, all of which are costly, but can preserve the barn for the next generation. This barn, which was under renovation in 2012, is near Squam Lake in Moultonborough. (Photograph by Ed Pape.)

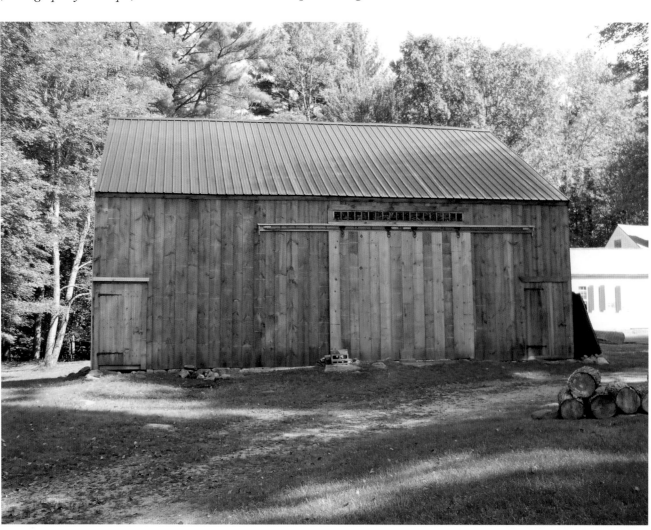

History of New Hampshire Barns

Early settlers in northern New England landed on the coast and gradually migrated inland as new townships were granted. With them, they brought traditional building methods from England. New England's different climate and plentiful supply of trees for timber and lumber led settlers to abandon some English practices and adapt others. Barns in England were designed for the threshing and storage of small grains. In New England, barns were modified to protect animals from the harsh winters. Barn types evolved further as agricultural production in New England changed from mere subsistence to commercial production under the influence of the Industrial and Green Revolutions. As lands were settled in the Midwest and West, Eastern farmers needed to become more efficient to offset the advantages of soil fertility in newfound farming regions. Over time, farmers also had to modify barn designs in response to production regulations imposed by the government and by progressive farming methods that were encouraged by Agricultural Land Grant Colleges (Visser 1997, 5–6).

The Rolfe Barn in Penacook was spared demolition with a groundswell of support from the community. It was part of one of the early settlements north of Concord. It was built as a double English barn, which is rare and an indication of a prosperous farm for its time. (Photograph by Lowell Fewster.)

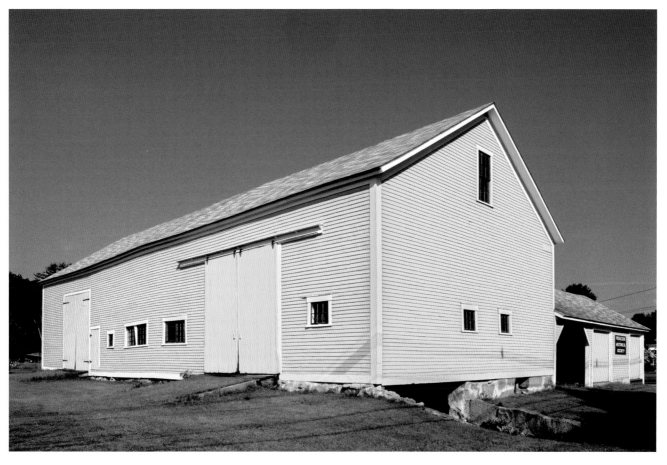

New Hampshire Barn Types

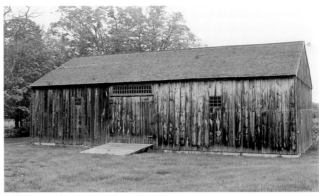

English Barns

For nearly two centuries, leading up to the early nineteenth century, New England farmers tended to use a traditional building design and form that is now called the English barn. Most English barns dating from the 1750s to the mid-1800s are approximately thirty feet deep by forty feet wide. These barns are built with a hand-hewn wooden frame, protected with a simple gable roof, and they feature a pair of hinged doors on the front side under the eaves. They were often built on a low, rock-rubble foundation with no basement.

The interiors of English barns are usually divided into three sections: a wooden threshing floor in the center, running perpendicular to the ridge; stables for animals on one side; and a bay for hay on the other side. Above the central threshing floor, there is often a high platform, called a hayloft or scaffold, which was used for

The old English barn typically had the entry door under the eaves and a lower pitched roof than the Yankee barns which would follow. (Photograph courtesy of Musterfield Farm Museum, North Sutton.)

additional hay storage. Sometimes double doors were located on both the front and back sides of the barn to encourage a cross breeze that helped in winnowing grain (Visser 1997, 61).

Additions were often added along the back side of English barns to provide more room for animal housing and feed storage. These additions often provided a place for snow accumulation, which could lead to a structural failure. This is located along Route 10 in Lyme.

Extended English Barns

As the small "standard" English barn became inadequate to meet expanded agricultural needs, farmers often built lean-to additions on the side or rear to provide more animal housing or hay storage. Sometimes they added one or more duplicate barns end to end, if space allowed, with multiple side doors. Generally, farmers tried to stable cattle on the south side, to take advantage of the warmth of the winter sun, and to store hay on the north side to serve as a buffer against the northwest winds (Visser 1997, 68–70).

Small English barns were often joined together end to end to meet the needs of larger farm enterprises in New England. This large barn on Route 10 in Grantham was two separate buildings. The two barns were moved across the meadow about 1830 by Ezra Elliot. They were placed end to end with a space in between to handle the manure from both barns. In 1870, the two barns were bridged together.

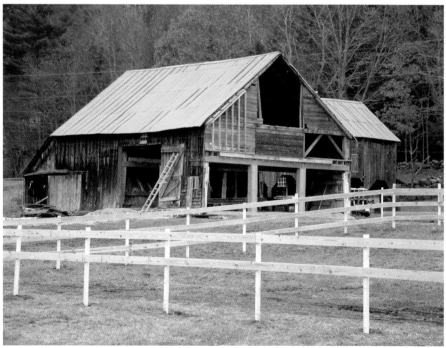

During an attempt by the new owner to repair this double English barn, it was discovered that the southern section of the barn was in dangerous condition and beyond repair, so it is being preserved as a single English barn.

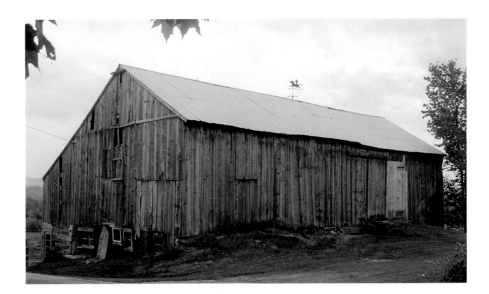

English bank barns allowed entry on upper ground level for hay wagons, and an extended front provided for a ground-level stable for cattle on the lower side. This is located on Stevens Road in Lebanon.

A common width for many gable-end barns was 36 feet. There were two 12' bays, separated by a 12'-wide drive-through alley. Sometimes the hay bay was 14' wide or more to allow for additional storage and this caused the large roll door to be off-center as shown on this barn in Hampton. This is an example of a very early Yankee barn, probably built in the late 1700s.

English Bank (Side-Hill) Barns

Early barns had no cellars. By the 1820s or 1830s, some New England farmers began to build their barns into the sides of hills to provide space for manure storage underneath the buildings. In the manner of the classic English barn, these buildings still had their doors on a long wall, at ground level on the uphill side. The other side of the building had an open cellar, accessible for efficient storage and removal of manure. This cellar could also be used to house animals like swine and to store equipment (Visser 1997, 70).

Gable-Front Barns (Yankee Barns)

As early as the 1790s and into the mid-1800s, some New England farms were adopting the new gable-front barn, with the growth of the dairy industry statewide. The Yankee barn is the style that many deem the most traditional in northern New England and is now the most common surviving barn type. The design is essentially an enlarged and reoriented modification of the English barn, with the doors relocated to the gable end and the interior reconfigured. Fortunately, quite a few of these locally fashioned structures remain today, as many were built during the heyday of New Hampshire agriculture.

In both English and Yankee barns, long and heavy framing timbers are connected to one

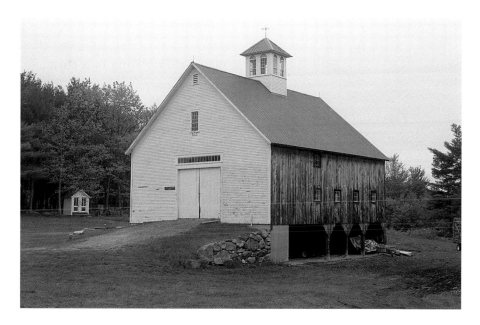

"Yankee Barns" had the main entry door in the gable end. The roofs usually were half pitch (45-degree angle). This provided more storage space as well as a very strong roof. This restored barn is at the Musterfield Farm Museum in North Sutton.

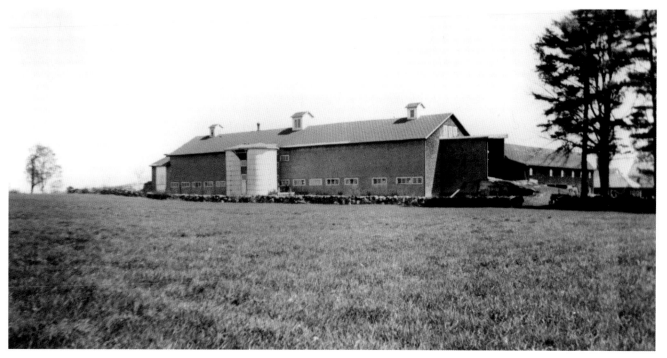

another by wood-pegged, mortise-and-tenon carpentry. The oldest barns feature hand-hewn timbers, physical evidence that dates these structures to before the mid-1800s. Later sawmill technology would allow the production of longer timbers used in barn framing.

The boards that enclose the roofs and walls and cover the floors in these early structures were sawn in water-powered "up-and-down" sawmills. Shorter framing members, such as braces, were also sawn in a mill. Both the boards and the framing members of later barns were usually cut by a circular saw after the 1850s. It is easy to differentiate the parallel saw marks of the up-and-down saw from the curved marks left by the circular saw. Although most barns have too few ornamental

The Canterbury Shaker Village cow barn was destroyed by fire in 1973, and only a foundation now remains. It was an example of one of the largest Yankee barns in the state. The 1858 barn was 200' long and 45' wide. The height of the barn on the front was 33', and it had 25' ramps constructed on both ends of the barn, bringing the total length to 250'. (Photograph courtesy of Canterbury Shaker Village.)

The Jones family operates a commercial dairy farm on Pleasant Street in Chichester. They made a deliberate decision in 2001 to renovate the 1850s Yankee barn rather than build a new facility. They milk sixty head of Holstein cattle. (Photograph by Jessica Matras.)

features to permit close dating from stylistic evidence alone, framing technology may permit reasonably close dating of a barn.

Yankee barns generally feature rafters (principal members of the roof frame) that are set at half pitch (sloping 45 degrees from horizontal), giving the roof maximum capacity to store loose hay. This style of gable roof also withstands the weight of snow loads remarkably well and became a standard design on most traditional northern New England farmhouses and barns. Later, when metal became available for covering these steep-sloped roofs, it allowed snow to slide off, reducing the effects of snow loading even further, unless the shedding of snow was obstructed by additions or lean-tos.

Yankee barns have large doors located on their gable ends rather than under the eaves. This arrangement offered several advantages that were suited to new farming methods of the early 1800s. The center drives of Yankee barns were wide enough for loaded wagons to pass through the building. Doors are often found on both ends of the building, permitting the wagons to drive straight through—a real advantage, since backing up a wagon is difficult. The greater length of these buildings offered increased stabling space for animals. Yankee barns could easily be made still larger by adding one or more bays (the twelve-to fourteen-foot-long structural units between posts). As in the English barn, stables were usually placed on the south side of the structure to gain warmth from the sun. Feed and equipment were usually stored on the often-windowless north side. Interestingly, farmers sometimes short-sightedly placed large round silos or additions at the ends of a barn, creating a serious barrier to future expansion.

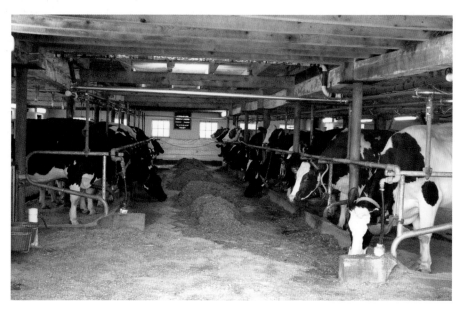

The Jones' barn was renovated to improve the floors, ceiling height, and ventilation. It has two double rows of cattle, two barn cleaners, and a multi-looped milking pipeline to improve efficiency.

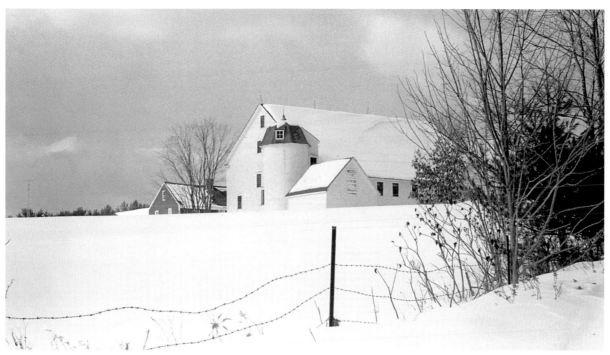

This barn is in West Concord and the dairy herd supplied milk for the area. It was originally part of the Farnum Homestead but was more recently known as the Hobbs Farm. The Haller Family has owned it since 1956. The barn was built in 1876 and had the silo attached to the end of the structure. Placement of structures on the end of the building limited the opportunities to expand these old Yankee barns.

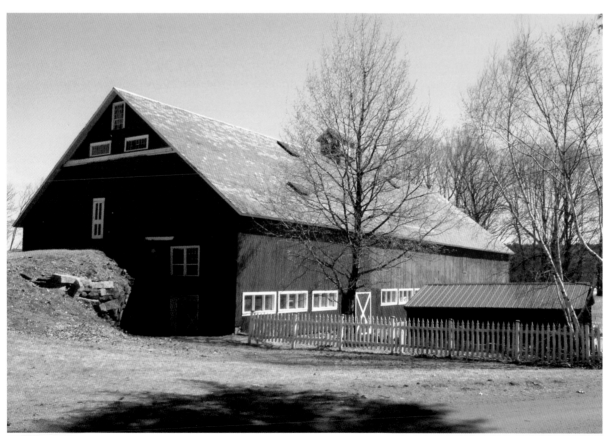

A barn bridge or wharfin allowed entry into the second floor of a gable-end barn to take advantage of gravity for unloading hay. The animal stable was often in the cellar. This is the Shaker Barn on Route 4-A, Enfield.

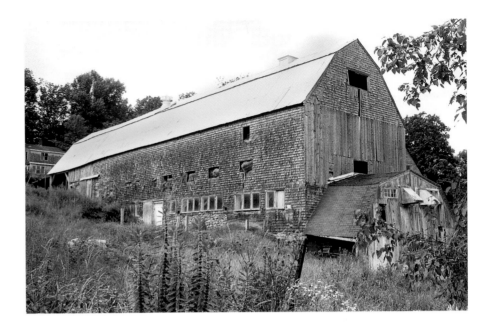

Some barns were three- to four-stories high and built into a bank to take advantage of gravity. Hay could be pitched from wagons and it would drop several feet to the hay mow floor. This barn is in Franconia with a view of Mount Washington.

Yankee Bank (Side-Hill) Barns

By the 1850s, many farmers were building barns with a cellar that permitted manure to be dropped and stored below the main floor. Building a gable-front barn along the side of an embankment provided both ground-level access to the main floor and access to a drive-in cellar below (Visser 1997, 76–82). Side-hill barn cellars with one open side provided for excellent manure storage and handling.

In the mid-1800s, farmers also began building three- or four-story barns that could be filled with hay and take full advantage of gravity. These "high-drive" bank barns provided access for loaded wagons near the top of the haymow so that the loose hay could be pitched down into the bays. As in other bank barns, manure could be dropped into the cellar. This type of barn was built into the side of a bank, but had a ramp, also known as a "bridge" or "wharfin" leading to its upper level. These ramps were sometimes covered (Visser 1997, 83–86).

Early New England barn types evolved with the needs of the farmers who used them, along with changes in period agricultural practices. The impacts of increased animal housing, such as the need for better ventilation, created challenges for early barn designs. Big farm animals produce huge

quantities of manure, a precious form of fertilizer. Until the advent of mechanization, manure handling was one of the more laborious of farm chores. When a cellar was provided beneath the tie-up, a scuttle opening covered by a trap door could be placed behind the animal stanchions for easy daily removal of manure. Swine were often kept in the warm barn cellar, and their rooting leveled out manure that otherwise tended to stack up under the scuttle. Storage in the barn cellar also sheltered manure from the rain, reducing the leaching of nutrients from a valuable animal byproduct that was the only available fertilizer until the common use of chemical fertilizers after World War II. Manure stored in barn cellars also protected ground-level foundation footings from the ravages of frost heaving.

Tighter wall sheathing and shingled or clapboarded siding caused ventilation problems that hadn't previously been an issue when barns had more air cracks and housed fewer animals. Later, sanitary regulations for milk production required smooth ceilings in cow barns, and the ceiling boards that were added to stall areas collected condensation because stored hay no longer provided insulation directly above the ceiling surface. The introduction of individual water bowls permitted cows to slop more water onto floors. All these

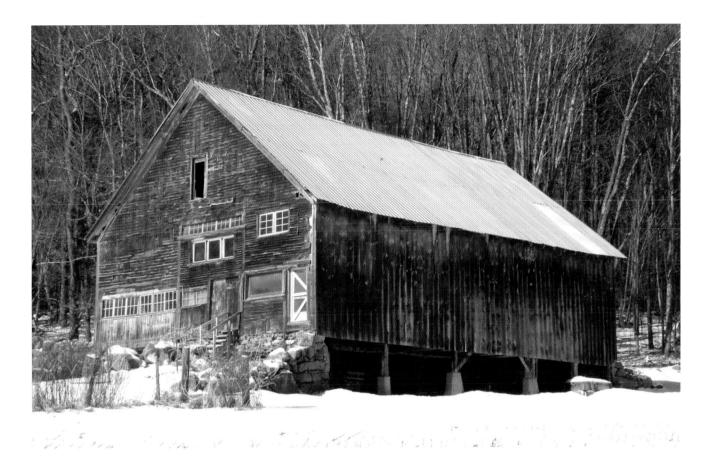

factors caused excessive condensation and unhealthy atmospheric conditions, which led to levels of barn deterioration that had not occurred when natural ventilation was ample. Initial attempts at ventilation were often ineffective. Vent stacks were often too small in cross-section. Poorly designed cupolas did little to alleviate developing moisture problems in these tighter barns. With the advent of electricity in the twentieth century, fans and air inlets were added to many existing barns to meet the demand for additional air exchange.

Side-hill barns with cellars allowed for manure storage and front access for cleaning out in the spring. These underneath areas were also used for animal shelter or storing equipment. This barn is on Route 3 in Boscawen.

Water bowls were added to barns to facilitate watering cattle mechanically. Animals often slopped the water as they drank, creating moist conditions on the feed floors, which caused deterioration of the structure. Newer barns have concrete floors.

Connected Farm Buildings

Many New England farmsteads are characterized by the connection of several buildings. Often the house was connected to a woodshed or summer kitchen and this was attached to a carriage shed that was connected to the barn. This stretch of buildings could be upwards of over 150 feet long. A popular explanation is the desirability of passage in the winter, where the farmer could go from the house to the barn early in the morning without being exposed to the elements. Thomas Hubka, an architecture professor, (Hubka 1984, 12) raises the question of why did a majority of New England

As barns were built with tighter construction and housed larger numbers of animals, provisions had to be made for ventilation. Cupolas ventilated the hay mows and sometimes were connected to wooden ducts that extended down to the stable level of the barn to exhaust animal odors. This barn is on Route 10 in Croydon.

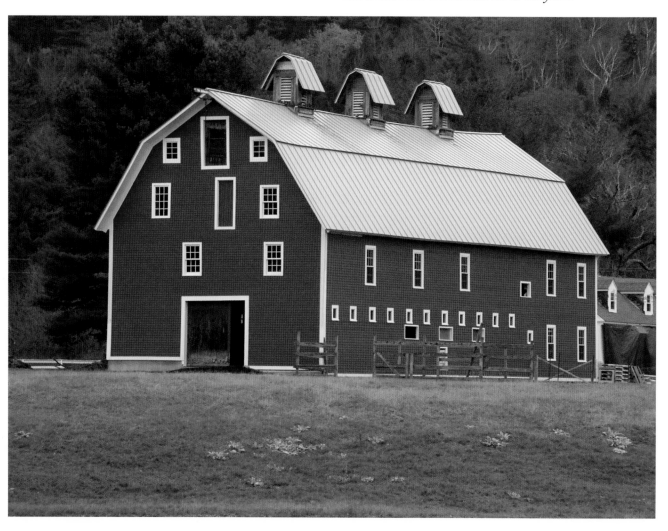

Connected farm buildings are common in New England. These were often thought to provide protection from the weather when going from the house to the barn, but more likely these additional buildings housed small home industries that allowed farmers to supplement their income. The New Hampshire Farm Museum in Milton has a set of buildings constructed from 1780 through the 1800s, with small additions in the early 1900s, and is a good example of this arrangement.

farmers wait until the middle of the nineteenth century to connect their houses and barns? One obvious disadvantage of the connected farm complex was its vulnerability to fire, and this could be an argument for its relatively limited time-period of popularity. When one building caught fire, usually the whole farm compound was lost.

Hubka's extensive study of New England's connected farm buildings (*Big House, Little House, Back House, Barn*) provides a convincing argument for this architectural compound. He has made the observation that New England farmers were struggling in the mid-to-late 1800s with the competition from the West and goods being transported across the country by railroad, and they needed both agricultural and nonagricultural production to survive. His research in the New England area showed that the coastal towns have lower densities of connected farmsteads than the inland towns, which may be due to the opportunities they had in maritime and trading enterprises. The coastal towns were also among the earlier areas settled, and by the late 1800s the soil productivity had declined and there were more urban pressures and industrial growth, thus it wasn't a thriving agricultural region (Hubka 1984, 20–25).

The set or sequence of older buildings that connected the main farmhouse and the newer and typically larger dairy barn contained home industries critical to the survival and success of the farm. These enterprises included making potash, candles, clothes, butter, cheese, shoes, barrels, and leather products, as well as taking in boarders. The home-industry became an indispensable component of the mixed farming system (Hubka 1984, 23, 192). As debates occur today about planning and zoning issues related to agritourism, it is obvious that there is a long history of farmers trying to stay competitive doing whatever it takes to make a living on the farm.

Village barns were often small structures attached to the house. These usually had provision for a light harness horse, family cow, and perhaps a buggy. This one is located in Contoocook village.

Carriage sheds could be attached or separate from the barn.

A turntable inside of a carriage shed was sometimes used to align wagons in storage so they could be pulled out and rotated into place to be hitched up to the horses.

Village Barns

During the 1800s and into the early 1900s, many in-town families had a cow for their personal milk supply, a light harness horse and buggy for transportation, and perhaps a pig and some sheep and poultry. To accommodate these animals and equipment, village houses often had a small attached barn called a village barn with a horse stall and a few stanchions for cows. The upper floor stored loose hay to feed the animals during the winter. Most towns and village centers throughout New Hampshire have homes with these small barns, which were often converted into garages during the twentieth century.

Carriage Sheds

Carriage sheds are typically separate, fancy buildings found at village and town residences. As carriages became popular in the late 1800s, these buildings were constructed to house them, and they usually featured one or more bays for storing a driving buggy and sometimes a standing stall area for the horse. Inside the structure there was also room for carriage accessories and storage hooks for the harnesses. More elaborate carriage sheds sometimes had internal turntable floors mounted on a wheel rail system. This made it possible for a wagon to be unhitched and rotated to a corner of the shed for storage, and then placed back on the turntable and turned into position for re-hitching to a horse and harness.

On the farm, the carriage shed might be attached to the house and have bays for storing the driving buggy and perhaps room for some of the farming implements such as the hay wagon and dump cart. These were generally narrow buildings with an open front. The door openings often had angled braces on each side of the top support or arched trim giving the building a more decorative and refined look than the other farm buildings.

Carriage sheds also served as small repair sheds and might contain a workbench, vice, and small tools. Various harness attachments, wagon parts, and horse shoes would be hung on the walls

or stored on shelves. A grinding stone for sharpening tools, wagon jacks, pitchforks, and hand rakes were among many of the tools that might be stored around the edges of the building.

North Country Logging Industry Horse Barns

Logging has always played a major role in northern New Hampshire. From the mid-1800s to the mid-1900s, horses were the main source of power for hauling logs from the woods. Large numbers of horses were often needed for this work. Roomy, basic barns were built near logging camps to hold as many as ninety draft horses, with hay stored in the upper levels of the building. Small villages, which might include a store, grist mill, sawmill, and boarding houses, often sprang up around logging camps.

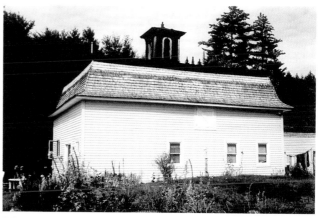

This mansard-roof barn housed horses for the lumber operations in the Crystal section of Stark. This style roof provided spacious hay storage overhead. This barn was part of a village center that included a grist mill and store. The building has been converted to living space, with the original cupola still in place.

This large horse barn was used for cows and horses during the time of the logging operations in the Percy section of Stark on North Road. It was said to have held ninety draft horses and over two hundred tons of hay and was used until the 1940s. The barn went into disrepair and burned in the late 1980s. (Photograph courtesy of Steve Turaj; information by Joe Dennehy.)

This estate farm in Wakefield has been in the same family since 1782. Richard Dow purchased it from John Schribner, whom he met while fighting in the Revolutionary War. The Dows ran a successful shipping business but lost almost everything in 1840, when there was a great depression. Later, using some inheritance money, Richard commissioned the building of the barn. The idea of the design came from some barns he had seen in England during his travels. The barn in the photo was completed in the mid–1880s and was used to house a herd of nearly two hundred head of registered Aberdeen Angus cattle.

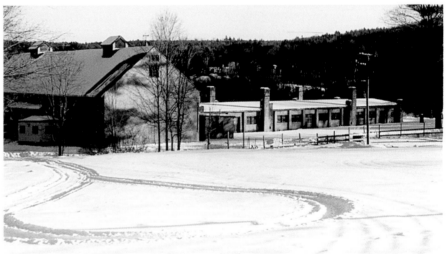

This old estate barn was built in 1881 and is still standing on the edge of Route 77, near the center of New Boston. It was known as the Whipple Farm, and the family ran the Parker House Hotel in Boston. They raised quality, registered Guernsey cattle and supplied food products to the hotels.

Estate Barns

During the mid-to-late 1800s and into the 1900s, wealthy businessmen and other notables sometimes invested heavily in building country estates. Railroad transportation enabled well-to-do urban families to escape the city and enjoy the serenity and freshness of the country. The owners lived on these country estates during the summer or on occasional weekends but would maintain a full staff year-round to operate the farm.

Summer estates were often extensive, with many outbuildings that incorporated the latest technology and made the farms nearly self-sufficient complexes. Estate barns on these properties were often designed by well-known architects. Such farms often raised fancy, purebred lines of livestock, such as dairy and beef cattle, sheep, and horses. Most estates had a mansion house for the owner, a home for the caretaker, and residences for other employees.

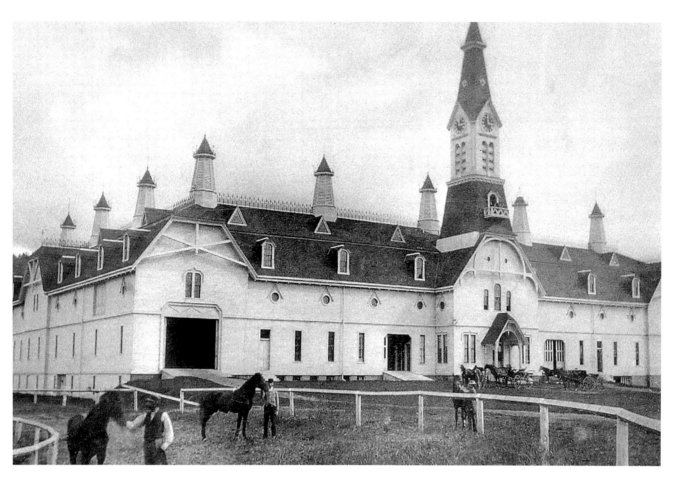

The former Pavilion Stock Farm was located south of Orford Village on the east side of what is now Route 10. Construction of this huge structure began in April 1877 and was completed the following winter. It was built and owned by Samuel S. Houghton, a Boston merchant, who owned the Pavilion Store on Tremont Street. The barn covered 22,800 square feet, the equivalent of over a half-acre. Its front measured 240 feet in length. The ell, which extended to the east, measured 200' x 60' at ground level. It was written that "It can easily accommodate two hundred horses with roomy apartments, and an eighth of them with sumptuous box stalls." Its architect was Calvin Ryder of Boston and the builder was S. S. Ordway of Lyndon, Vermont. The barn fell into disrepair in the late 1920s and burned in July of 1930. (Photograph courtesy of Mrs. Julia Fifield. Information was taken from the Manchester Mirror and Farmer and compiled by Carl Schmidt.)

Estate barns had unique architectural features that made them decorative as well as functional. The farms were often owned by wealthy businessmen who hired managers to maintain horses or fancy livestock. This barn was part of the Corbin estate, built in the mid-1800s to store feed for the animals in Corbin Park. An elaborate cupola once adorned the center ridge of this barn. It is known as the Sichol Farm and is located on Route 10 in Newport. (Photograph by Lowell Fewster.)

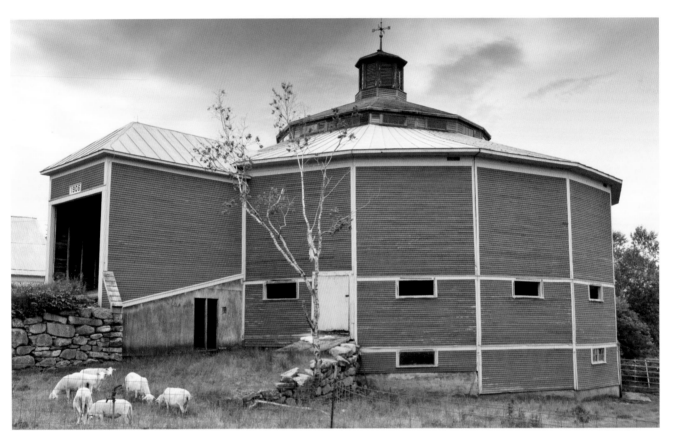

Round Barns

Round barns were sometimes built in the late 1800s and early 1900s on the theory that they were labor-efficient. The idea was that hay storage, or a silo, could be in the center and the animals housed in a circle around the outside perimeter. The concept didn't gain widespread favor and they were difficult to build. Few of these barns were erected, and only a small number remain around the New England area.

Round barns were promoted as efficient structures, but the concept never became popular. One of the few existing round barns in New Hampshire is on Route 10 in Piermont. It is eighty feet in diameter and has sixteen sides. The barn was built in 1906 by the Stevens family from lumber cut on the farm. It replaced two smaller barns built around 1800. (Photograph by Lowell Fewster.)

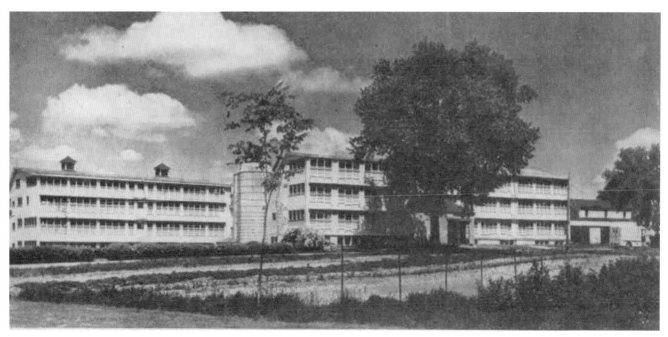

Christie poultry barns in Stratham, circa 1951. (Photograph courtesy of Nathan Merrill.)

LEFT: *This poultry barn in Canterbury is typical of what dotted the countryside at the peak of the poultry industry in the 1940s. This barn was part of the Wheeler Brothers' poultry farm. The main barn was constructed in the mid-1800s and was converted from a livestock barn to four levels of housing for poultry prior to 1940. The first poultry produced hatching eggs, which were sold to a hatchery; then in about 1940, they changed to growing birds for table eggs and sold to market. The brothers continued to farm until retiring in about 1979. (Photograph by Lowell Fewster.)*

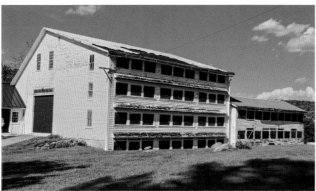

Poultry Barns

The poultry industry was in its heyday in New Hampshire in the early to mid-twentieth century. Multi-story hen houses were erected all over the state's countryside and millions of birds were raised for egg production. These structures usually feature a lot of windows on the south side to provide light needed to promote egg production. The barns were often of light-duty construction. In the 1930s, about one million hens were laying eggs in the state, and the industry grew to three million hens by 1952. Many old Yankee barns were adapted to poultry, which is evidenced by many windows added to the second floor. When the poultry industry moved south where there were cheaper grain prices, these lightly constructed poultry barns soon fell into disrepair, and many have since collapsed.

Ground-Level Stable Barns

Many new barns constructed during the first half of the twentieth century were built on a radically new plan. These barns have low, ground-level first stories finished with easily cleaned concrete floors that were at first encouraged in the 1950s, then required in the 1960s with the introduction of the PMO (Pasteurized Milk Ordinance). Above these stable areas are huge gambrel roofs, built of standardized two-inch-thick sawn lumber, which permitted the storage of the great volumes of hay that were required by enlarged dairy herds. High gambrel roofs were framed with rigid trusses

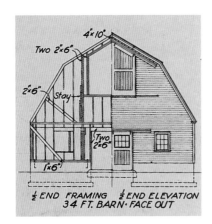

The gambrel roof design created an open second floor for baled hay storage. (Source: Plan #5526, circa 1948, USDA Plan Service.)

RIGHT: *The gambrel roof barns built in the early to mid-twentieth century were designed with the cattle stable on the ground floor and provided for much hay storage in the second story. This barn was built in the early 1950s to replace smaller, less efficient facilities and is in Concord.*

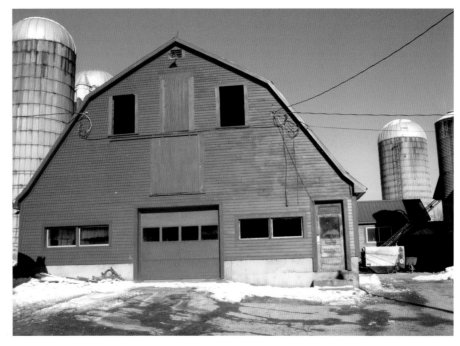

beneath the outer slopes of the roof requiring no internal supporting posts. Barns of this period became increasingly mechanized, with electric-powered gutter cleaners, feed carts, silo unloaders, conveyors, and around-the-barn milk pipelines.

Single-Story Stanchion Barns

By the 1950s, single-story stanchion cow barns became popular. These buildings had trussed roofs, eliminating the need for objectionable posts in the stable area. Hay was stored in a nearby or attached building, often an older Yankee barn. Many farms used less hay and depended upon corn and hay-crop silages, stored in adjacent silos, as the dominant source of roughage. Mechanical gutter cleaners conveyed manure to outside stacks.

Stonewall Farm in Keene is an example of a barn built in 2000 away from the old farmstead to take advantage of new building techniques. It has a truss roof construction and is naturally ventilated. Stonewall Farm is a non-profit educational farm serving the greater region.

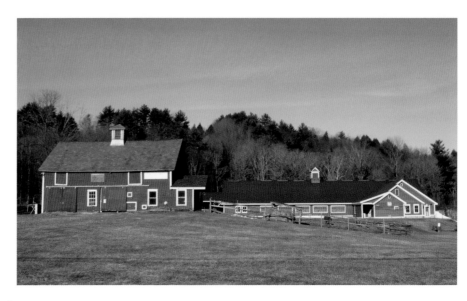

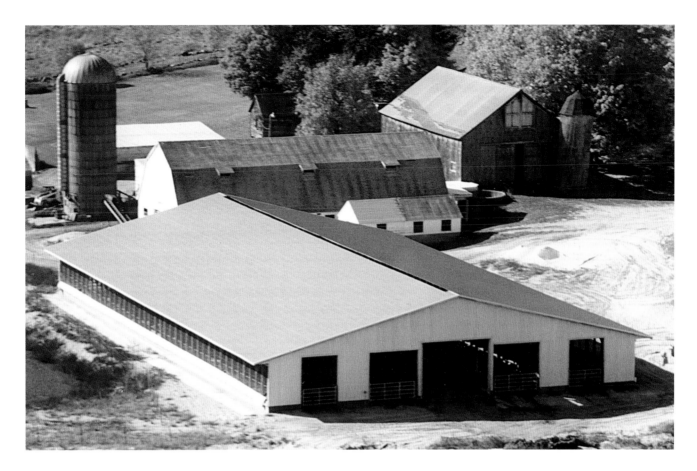

Free-Stall Barns

Another radically new form of dairy barn appeared during the last half of the twentieth century. First called "loose housing barns," these buildings allowed cows to loaf on deep layers of bedding called "bedded packs." Stalls were then added to reduce bedding use, and these buildings began to be referred to as "free-stall barns." Free-stall barns are now the dominant dairy management system. Cows have free access to comfortable stalls of their choice, as well as feed and water. These structures are generally one-story, low-pitched roof, pole barns and kept quite open for natural ventilation. The early free-stall barns had open fronts to the south, with an eaves-line feed bunk. Later, the drive-through style became more common, with a center alley for delivering feed. This also provided the ability to group cows in four quadrants of the stall area along both sides of the open feed floor.

The attached milking parlor and holding area building make it possible to milk many more cows, faster, and in a clean environment, while allowing workers to stand upright as they operate the milking equipment. Where farmers formerly went to feed and milk cows that were tied in one place, cows now go to feed themselves and are driven to the farmer to be milked in the milking center. This innovation in dairy housing has made it possible for fewer workers to manage large herds of cows efficiently.

In Epsom, along Route 28, is a classic example of the evolution of agriculture in the Northeast and the change in barn styles to meet that need. On the extreme right is the original old barn, built in 1852. Adjoining that is a hip roofed barn built in 1956 with a concrete stable floor to meet public health regulations. In the foreground is a modern, free-stall barn built in 1996 to improve labor efficiency and accommodate an expanding herd. More recently a milking parlor has also been added beside the free-stall barn. (Photograph courtesy of A&B Lumber.)

Fabric Structures

In the late twentieth century and the early twenty-first century, concern grew about urban sprawl in New England. Planners wondered how to sustain farms near expanding cities and towns. Because farms are threatened by expanding development, some new structures were built with tubular metal frames and a minimum of concrete. They are cheaper to construct than permanent buildings and could be disassembled and rebuilt if the farm had to relocate. These structures are constructed with double-layer plastic over hoops, or with heavier canvas-like vinyl material stretched over curved, metal hoop-frames.

Fabric structures have gained some popularity as a lower-cost option for dairy cattle. Some early ones were gutter-connected greenhouse structures, but now the single-hoop barns are used with a heavy vinyl roof material. They are often mounted on wooden walls to protect the sidewalls and allow for ventilation.

The drive-through free-stall barn design became popular in the 1990s. This allowed for grouping of cows according to production and feeding with mixer wagons without mingling with the animals. This large free-stall barn at the Tullar Farm in Orford has feeding along the sides to accommodate the center-alley robotic milking. It was built in 2012, and the robotic milking units were added in 2014. The barn is 170 feet wide and houses 480 head of dairy cattle.

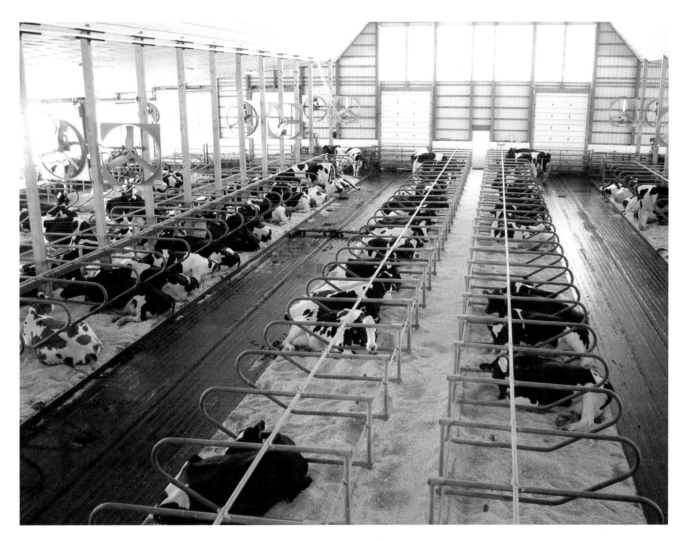

Automatic Milking Systems Barns

The latest technology to be adopted in the dairy industry is automatic milking, which allows for a cow to be milked with no human involvement. This has once again greatly changed barn design. Now very wide barns are needed which contain both the animal housing and the robots which do the automatic milking. There needs to be a minimum of disturbance within the barn, so it won't interrupt the cow's routine of going on her own to be milked. Usually the feed bunks are located along the outside walls, allowing the feeding equipment to pass by and not mingle with the animals. Automatic alley scrapers clean the barn, and about the only disturbance is the occasional filling of the stalls with fresh bedding. There are adjustable holding pens around each robot unit, which are used to train new heifers or deal with problem cows.

Robotic milking has drastically changed barn design. Now barns are designed for the free flow of cattle to get to the robotic milking units. There needs to be a minimum of disturbance in the barn, so often the feed bunks are along the outside edge and the barn is automatically cleaned with alley scrapers.

The robot milking units are spaced within the cattle housing area, and the cows are enticed to be milked by offering grain in the unit. The combination of the feed and the cow's sensation of a full udder needing to be relieved, cause each cow to enter the milking unit two to three times a day. These units cost nearly $200,000 each, and one robot can handle 50–60 cows, so multiple units are needed on a large farm.

The robotic milking units are equipped with computers, which recognize the cow from a transponder on her neck and memorize her teat placement, so the machine can clean the udder

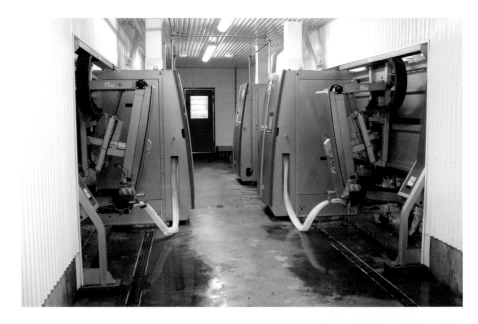

Milking with robots eliminates the need for a separate milking parlor with a holding area for milking the cows. The robot units are contained within an environmentally controlled room inside of the cattle housing barn, and they are easily accessible for cows to enter with the enticement of some grain.

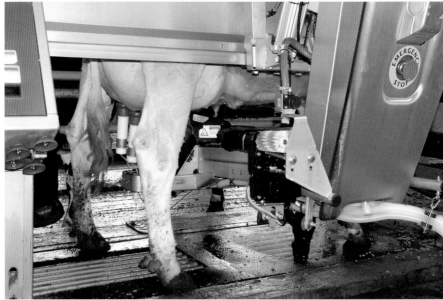

As the cow enters the robot from the free-stall barn, the robot recognizes the cow from a transponder worn around the neck. Upon completion of milking, the unit is detached, and the cow exits the robot.

and automatically attach the milking unit. It senses when she is done milking and removes the milking unit and dips the teats in disinfectant, encouraging her to exit. The milk is transferred by stainless-steel piping to the milk room and wash water is plumbed to each unit for automatic washing. While the cow is being milked, data is collected about production, milk quality, and milking time, and then this information is sent to a computer data bank. If anything abnormal occurs during the milking process, the farmer is called by the unit on a cell phone so he or she can come to the barn and check things out.

Robots may be the trend of the future for milking cows to save labor, and improvements are continually being made to improve the flow of cows through the units, the thoroughness of milking, and the number of visits by the cow to the unit per day.

Architectural Characteristics

Many types of New England barns share common architectural components. At any given period, intended uses, available materials, and technological and stylistic developments dictated various types of lumber, windows, siding, and other functional and decorative features.

Most barns built prior to the mid-to-late nineteenth century were generally of post and beam construction with notched joints. Before the 1800s, most framing members were hand-hewn because of the limited capacity of saw mills. From the late 1700s to about the 1830s, there were up-and-down water-powered saw mills, and these were often used only to saw out brace materials and board siding, as the saw carriage had limited capacity for length. Then with the development of the circular saw around 1830, most short lumber was cut in these mills. By the late 1800s, the circular saw mills had greater carriage capacity and could saw out the forty-foot-long beams needed for barn building.

Generally, barns were built with whatever wood species were abundant on the property. White pine or hemlock were the woods of

Hand-hewn beams are distinguishable by the rough tool marks left in the wood. A barn with all hand-hewn timbers will generally pre-date to the mid 1800s. This shows the characteristic gunstock post, which flared out at the top to accept the intersecting beams. As saw mills became more prevalent, later barns were built with a combination of hand-hewn and sawed lumber.

choice, but sometimes beech, chestnut, or oak were used. The softer woods were easier to hew into square beams. Preparations to build a barn might start a year in advance, getting the trees cut into logs and dragging them into a staging area to be prepared for hewing. A lot of time was spent preparing the building site itself, as it needed to be cleared of rocks and stumps, and if necessary, its hillside excavated for a bank barn and rocks put into place for a foundation.

Most barn beams were shaped with a broad axe, which is an axe with an extra wide blade and sometimes a little bend to the handle to help in swinging it. An adze, a tool more like a wide-blade pick axe, is sometimes used for fancier, more prominent beams. The well-known "cut-and-sliced" beams were first cut vertically with a scoring axe and then sliced with the broad axe. This work was done by skilled craftsmen, and the logs were fashioned into straight and square timbers. Crews of joiners were hired to prepare the logs, cut the joints, and fit the joints into place. Sometimes joints were pinned with temporary trunnels (tree nails) called drift pins, which could be easily hammered out and replaced with permanent pins prior to erecting the barn.

There were many very specific joints which were shaped for various components of the barn. Around the top of the foundation were the wooden beams called the sill. Notches were cut into the sill to accept the horizontal floor beams. The sills were also notched out or mortised in the corners and along the length to receive the vertical posts. The frame was built on the ground in sections called bents, which were tilted up into place. It took a lot of skill and careful measuring to create bents which tightly fitted together. All the joints were chiseled-out mortises and tenons, driven together with a heavy wooden mallet called a beetle.

Large groups of men were invited to help lift the bents into place with ropes and pulleys, guided by the use of fifteen-to-twenty-foot-long poles called pikes, with sharp iron spikes on the ends to hold the bents upright until they could be firmly anchored and braced. Once the frame was together, the roofing and siding were sometimes left for the farmer and his family to do and the skilled workers pulled out (Klamkin 1979, 28–32; Hubka 1984, 157).

Scribe Rule and Square Rule Construction

Early barn construction followed an English framing tradition, called the "scribe rule" method. In this system of building, every joint is custom-made and is like no other. Adjacent framing members have numerals, called "marriage marks," incised into their faces to indicate which pieces fit together. The mortise was cut into the receiving timber and the tenon was fashioned at the end of the other timber. After the joint was roughly made, the irregular surfaces of the adjoining wood were scribed to a matching profile and the excess wood was pared away with a framing chisel.

During the early 1800s, builders began to adopt a new style of carpentry in which similar joints were made interchangeable. All framing members were accurately measured and cut to a pattern. This new technique was called the "square rule" method. Square rule framing required that the seat of each joint be chiseled down below the irregular surface of the hewn timber so that all the seats would be equidistant from lines drawn on the timber. The result is a noticeable cutting away of the outer surface of the timber at each joint, a clue that the carpenter was using the new, standardized framing method (Visser 1997, 19–20).

Beam joints and marriage marks.
(Photograph by Lowell Fewster.)

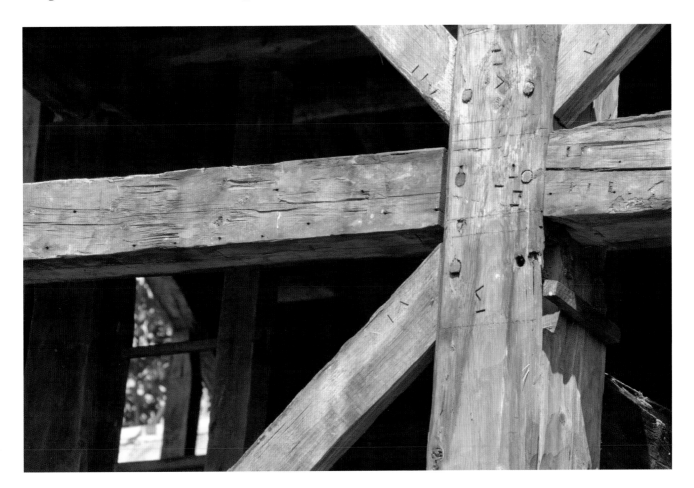

Sawn Timber

The earliest form of sawn timber was "pit-sawn." This was done by hand with a two-man rip saw with one person standing in a pit pulling down on the saw and another standing above pulling it up.

From the time of first settlement until the 1850s, lumber was also sawn in water-powered sawmills that used reciprocating or "up-and-down" machinery. Between the 1850s and the 1870s, many of these mechanisms were replaced by circular saws, which were far faster, although some older up-and-down mills continued in operation into the twentieth century (Visser 1997, 26–30). The invention of the circular saw resulted in the production of uniform framing members, which efficiently supported the square rule method, and typically there was the switch from the major rafter and purlin frames to the common rafters in roof construction. Despite the increasing adoption of smaller-dimension sawn lumber, traditional post-and-beam framing persisted in New England until the early twentieth century.

Most farm buildings prior to the 1850s have planks and boards cut by water-powered sawmills equipped with up-and-down saws. These were vertical, reciprocating blades that cut through the logs, leaving ragged saw marks. This mill was known as the Nicholas-Colby Mill in Bow. It was a rare survivor from the early nineteenth century, until it was demolished by the high waters of the 1938 hurricane. (Picture courtesy of the New Hampshire Historical Society Tuck Library.)

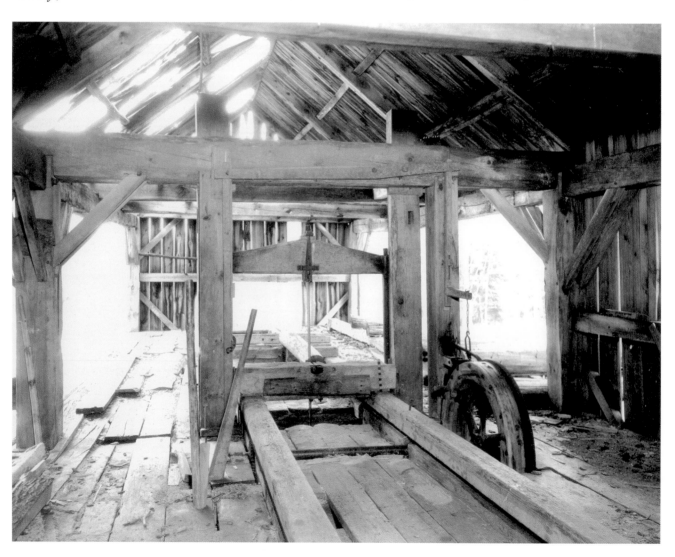

Balloon Framing

Balloon framing began to replace post-and-beam construction in New England after the 1870s and became popular by the early 1900s. In place of heavy timbers, balloon framing employs a multitude of identical wooden framing elements of relatively small dimensions fastened in place with nails instead of mortise-and-tenon joints. Balloon framing took advantage of the products of the circular sawmill and required less skill than traditional heavy-timber carpentry. For house construction, balloon framing used 2" x 4" wall studs. The heavier type of balloon framing used in barn construction employed 2" x 6" or 2" x 8" studs and was referred to in early twentieth-century literature as "plank framing."

Wall Sheathing

Until the early 1800s, most barn walls were covered with a single layer of pine boards, applied vertically to shed water. As these boards shrank, the cracks admitted light and provided ventilation. Barn walls in the mid-1800s were often made tighter by nailing thin boards on the inside, over the cracks, or by nailing boards of a full-inch thickness over the exterior face of the wall. Board-and-batten siding, in which

Old English barns were often single-boarded and as the lumber shrank, the cracks between the boards allowed for natural ventilation.

Wooden shingles were commonplace in the nineteenth century and were used to cover exterior walls (as shown on the left side wall). On the front of this barn are clapboards, which were used after the mid-1800s when machinery had been developed to do this type of milling.

a narrow exterior batten covers the crack between adjacent vertical boards, was also popular by the mid-1800s.

As water-powered shingle mills became commonplace in the nineteenth century, barn walls were often covered with inexpensive shingles sawn from native white pine. By the 1860s, machinery was developed to saw clapboards, which had previously been split and shaved by hand. Clapboards were nailed horizontally, with some overlap, to provide a tight and waterproof covering for exterior walls. In New England it is common to see the more expensive clapboards on the road side of the barn and wood shingles on the other three sides. After about 1910, barn walls were often protected with exterior coverings made of cement-asbestos, asphalt-felt, or metal. Though often unattractive, these new products performed their function well, often preserving the vertical boarding to this day. Plywood and other sheet materials were often used to cover barns in the latter part of the twentieth century. Ship-lap lumber has a rabbited edge and is a good vertical boarding option on a barn, and the over-lapping minimizes open cracks.

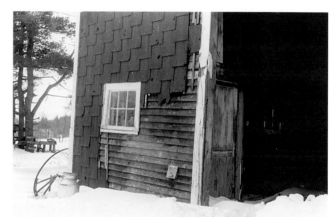

In the early to mid-1900s, barn walls were often covered with asphalt or asbestos siding. Although not attractive, it protected the wood coverings beneath. The owners of this 1886 barn plan to preserve the character of this structure with original-type covering materials.

Special Features of Old Barns

Old barns have many unique and character-defining features which are integral to their use, purpose, and design. Sometimes these are taken for granted and overlooked by the casual observer. In the days when these early barns were built, materials were scarce and everything that was used had a purpose. Whether a brace, built-in ladder, pitching hole, or even a nail in the wall, there was a practical reason for it. There can be great pleasure in walking through a barn and carefully noting its special features and pondering the reason for their existence. What we call "reading the barn" can be like solving a mystery.

Structural and Building Components

Framework

The first and most prominent aspects of a barn are its structural and building components. The main framework is often called the "bones" of the barn. As you look among the maze of timbers, there is a very systematic arrangement of vertical and horizontal beams that ascend upward to form the general outline of straight sides and a pitched roof. These are all meticulously joined together with notches and pegs to form a very rigid structure. Then the "skin" or the exterior boards are

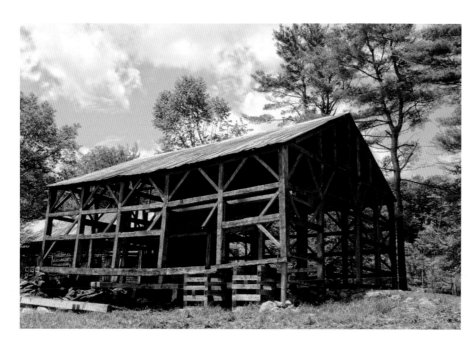

Framework: "the bones" of the barn. (Photograph by Beverly Thomas.)

fastened to this framework or skeleton to create the structure of a barn. Barns were usually built in increments of twelve-foot sections or bents, which were connected and pushed up into place by large groups of men and fastened into place. The notching and joining was very sophisticated and often done by a professional joinery crew who worked with the local farmer and his neighbors.

The vertical posts of early barns (1700s to mid-1800s) were usually a gunstock design, which meant they flared out at the top to create a larger surface to carry the intersection of horizontal support members and roof rafters. These would have been hand hewn with a broad axe and adze. On top of the vertical posts would be a long plate running parallel to the eaves, which might be a beam upwards of forty feet long or longer. There were various designs for how these plates were attached to the posts, including notched into the side or even dropped down a few inches from the top. The dropped-plate was often characteristic of some of the later, fancier barns of the late 1800s,

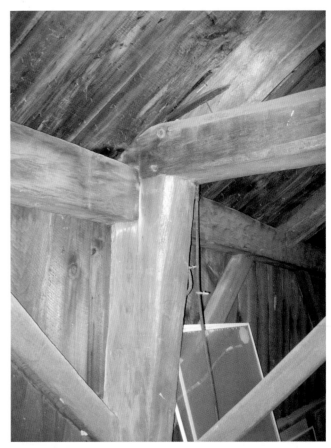

Gunstock post, which flares out at the top to support the intersection of timbers. (Photograph by Beverly Thomas.)

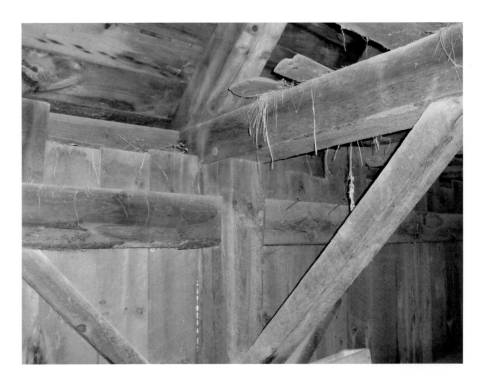

Dropped-plate frames were for another building style that allowed for an eaves overhang. (Photograph by Beverly Thomas.)

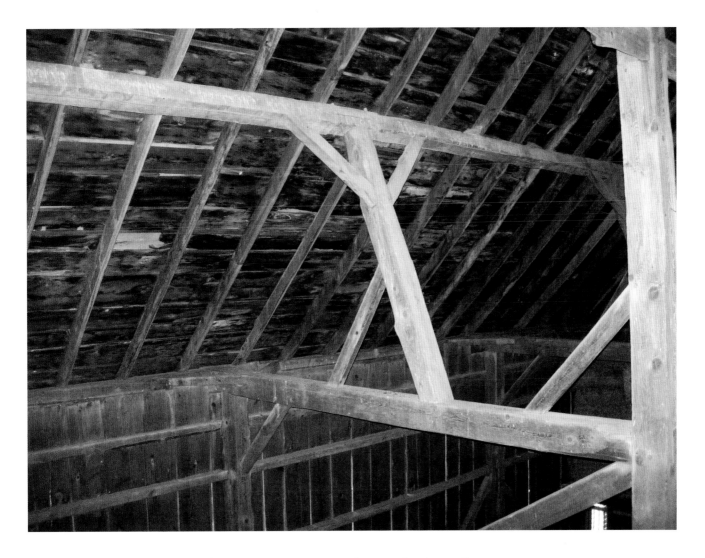

Roof bracing. (Photograph by Beverly Thomas.)

and it allowed part of the rafter structure to protrude outside the wall of the barn to form the framing for a decorative soffit.

The barn's roof structure generally consisted of large rafters spaced over the vertical posts and then horizontal purlins notched in between for nailing the roof boards, which ran up and down vertically on the older barns. There were various construction styles of angled braces running from the ridgepole to the rafters and, later, more bracing and supports with smaller lumber between the rafters. Some bents had a center king post which extended from a beam up to the ridge pole, and these created a problem with the advent of the hay fork and were sometimes removed, weakening the structure. A barn with the boards running horizontal on the roof with closely-spaced common rafters is often an indication of construction in the later 1800s.

Since open land was so precious, barns were often built on the poorest land on the farm. This meant that sometimes barns were sited over ledge, on a side hill, or in a rocky spot. If it was rough terrain, there might be just piles of rocks under the load-bearing points of the sill. Since these barns were so over-designed with large beams, it

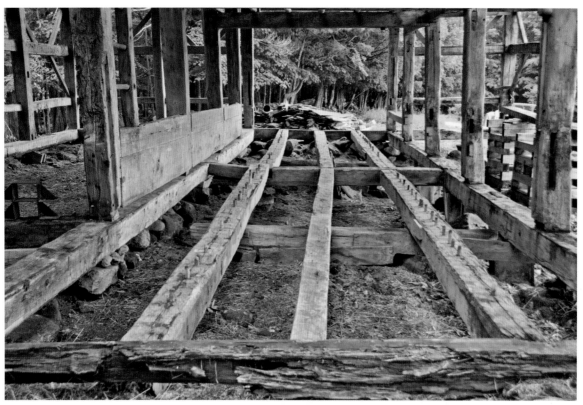

Floor structure with the large beams and connecting supports. Note the wooden pegs that fastened the floor boards to the support beams. (Photograph by Beverly Thomas.)

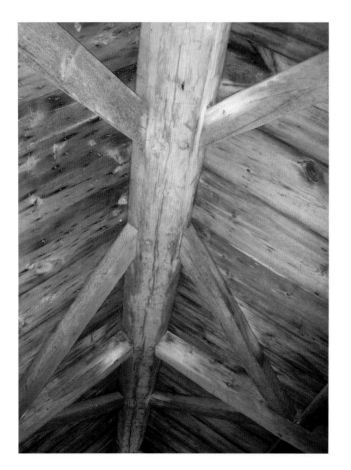

wasn't necessary to have support in between. The side-hill barns usually had a fieldstone foundation on three sides and a basement that opened to the south or the east for a protected winter exposure for animal turn-out in the winter. The floor structures for these barns consisted of large beams notched into the perimeter sills and then running to internal beams either supported by rocks on the ground or internal posts in the basement. The animal side of the barn generally had a raised platform for the cows or horses to stand on and a recessed gutter to contain the manure, and the central barn floor and hay mow had a double-planked floor. The tie-up area usually had a low ceiling to maintain warmth in the stable and provide a place above to store hay.

Early pentagonal ridge pole with bracing. (Photograph by Beverly Thomas.)

Doors

Barn doors were strategically placed for animal and human movement. In the old English barns, the main entrance to the barn floor was under the eaves on the long side of the structure and was generally two hinged doors which swung out. These had long strap hinges mounted on pins, as these could be fabricated by a blacksmith. Typically, there would be a separate side door in the stable for turning cattle out to pasture. Usually animal passage doors were in the corner, rather than in the center, so cows couldn't miss the exit heading out. These doors were also mounted on smaller versions of strap hinges and usually were wider than those for human passage. If a barn had a mature cow section and a young heifer area, there might be a door in each corner of the side wall for letting them out each end of the barn.

In the later Yankee barns, the main entrance was in the gable end of the structure, which prevented snow build-up in front of the doors in the winter. Early Yankee barns had double swinging doors, but then the roll door became more common. These could be one large door or two sections and have roller wheels mounted on top which would move along a track. A further refinement of this was the pocket door, where the door slid inside, and provisions had to be made in the beam construction for the door to pass. Occasionally there were variations to these features. These include a bottom wheel to aid in movement, a window located in the middle of a roll door for additional light into the barn floor, or a passage door to avoid opening a large door to enter the barn.

Barn doors were generally vertically boarded, with internal cross bracing. They were fastened shut with a hook and eye lock. Sometimes there was a simple door spring mounted on a hinged door so it would shut after the last animal entered, keeping unwanted animals out. Outside the barn door there was often a large, wide piece of granite, which served as a step to mediate the difference in elevation between the barnyard and the support sill.

Cow door in the corner of the barn. (Photograph by Beverly Thomas.)

Pocket door, which rolls within the building. (Photograph by Lowell Fewster.)

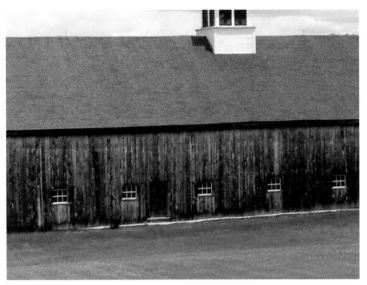

Cow stables typically had single sash windows with three panes over three panes on the south side.

Horse barn window, which is small and protected.

Windows

Generally old barns didn't have a lot of windows, and they were usually located only on the animal-housing side of the barn. It was common for Yankee barns to have an east-west ridge pole, where the south side was a cow stable and the north side was the hay mow. There were very few windows on the hay mow side because sun shining in could bleach out the hay and make it less palatable, in addition to the risk of breaking window panes with the hay moving operations and the use of mechanical hay tongs and pitch forks.

Normally there are transom windows over each set of doors leading to the main barn floor. These are usually a series of single panes in a frame over the width of the door. Occasionally you'll see a small dormer window on the side of a barn roof, and this is an indication that there had been an internal silo, where the window served as an opening for a conveyor or blower pipe to transfer the cut silage into the silo. If a barn has multiple sash windows on the second floor or hay mow side, this usually means that it had been converted from dairy to poultry use in the heyday of the poultry industry and additional light was needed to promote egg production.

The windows in the cow stable are usually single sash with three panes over three panes. Double-hung windows aren't practical in a cow stable, because a lot of moisture is given off with cows breathing and chewing their cud, and the windows will swell and jam tight. These single sash windows were installed so they could tip in at the top and a nail would be stuck in various holes in the window frame to hold the window open slightly to let in air for ventilation. In the summer, they could be completely removed.

Horse barns typically have small windows located high above the floor in each stall. This is because horses are tall and like to "crib" or chew wood. Placing the windows up high and out of the way can help to reduce this problem, and sometimes such windows have vertical rods or grates over them for additional protection.

Internal Features

Stables

A very high percentage of the barns built in the mid-to-late 1800s were dairy barns. Almost every farm had five to six cows and sold butter on the open market as a cash crop. Then about 1900, fluid milk became a common commodity with the advent of oleo margarine replacing some of the butter market. The reason for the magic number of six cows is that's about the limit of what a person could milk in one sitting by hand. There were some specialty sheep barns characterized by only hay storage on the second floor and a run-in basement on the front, south side; however, sheep need a minimum of housing and a lot of sheep were either housed in simple shelters on the edges of fields or in the basement of dairy barns.

Dairy cows needed to be restrained to hold them in place for milking and to individually feed them hay and grain relative to their daily milk production. The early restraints were as simple as a pole off to the side of a manger opening, with a ring and chain attached to it. One end of the chain had a short, metal rod which could inter-lock into a chain link and secure the cow. Later, stanchions became a popular method of restraining cows. The first ones were wooden stocks which opened and then latched at the top. Later they were made of steel with wooden inner liners against the cow's neck. The typical layout of a barn was a row of stanchions on the south side, a center barn floor and a hay mow along the north side. There was a ceiling above the stable to make

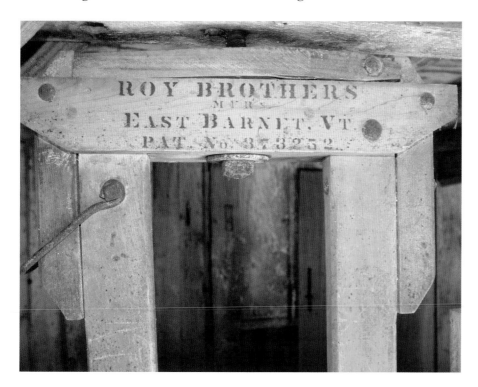

Wooden stanchions were common in early dairy stables, and the Roy Brothers Manufacturers in East Barnet, Vermont, were a common supplier.

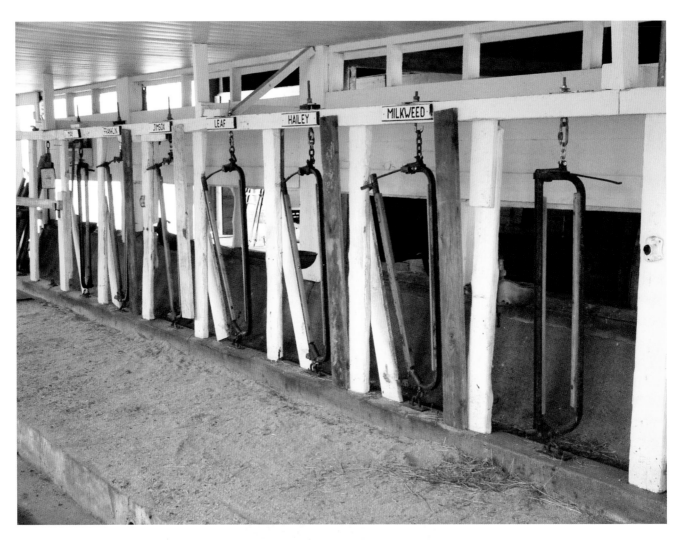

Cow stanchions for securing the
cattle in the stable.

Gutter and scuttle hole for pushing
the manure into the basement.

the space warm and provide a place for additional hay storage, which also functioned as insulation.

The cows stood on a raised platform, positioned so it would create a drop for a gutter behind them, which sunk below the walking floor level to create containment for the manure. Often floor openings, called scuttle holes, were built-in on the walkway side of the gutter. These were usually about twelve inches wide and thirty-six inches long and mounted on hinges. When cleaning the barn, the covers could be lifted, and the manure was shoveled along the gutter and pushed down into the basement for winter storage. Several holes were spaced evenly down the length of the stable, so the manure didn't have to be carried very far.

In front of the cows was a manger about two-to-three feet wide where the grain and hay were fed to the cows. The drop-down doors in front of the manger were about chest level for the cows and allowed for the grain and hay to be tossed in from the central barn floor. These

Cow feeding area with openings into the central barn floor.

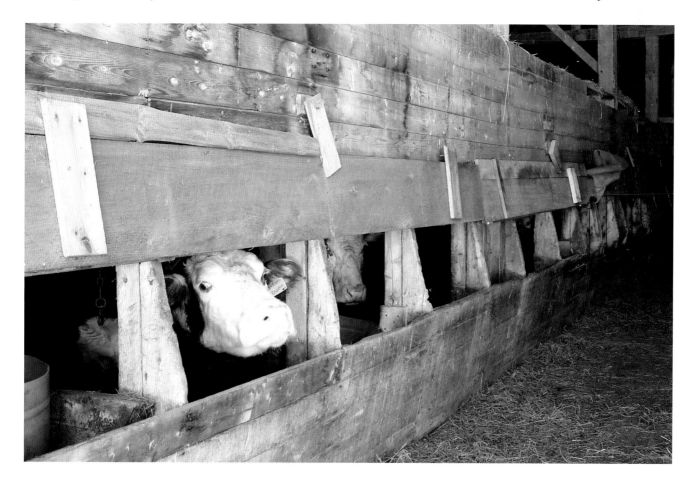

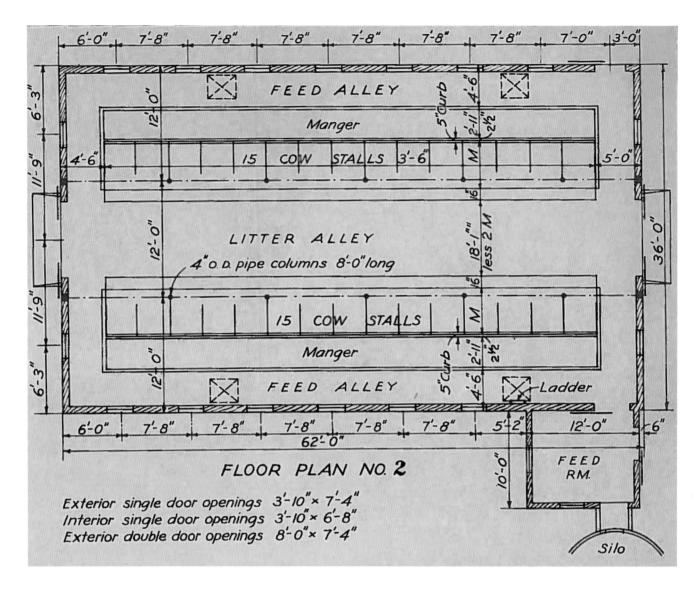

FLOOR PLAN NO. 2

Exterior single door openings 3'-10" × 7'-4"
Interior single door openings 3'-10" × 6'-8"
Exterior double door openings 8'-0" × 7'-4"

doors remained closed in the winter to keep the animal heat in the stable but were dropped open in the summer for ventilation. There were no provisions for water because it would freeze in the winter, and the cows were turned out twice a day to the barnyard, where there was a water trough for them to drink.

Later, cow stables were usually built on concrete and the cows were housed in two rows within the entire width of the first floor, either head-to-head or tail-to-tail with hay storage above. As already noted, the more modern barns now have free-stall arrangements.

The newer dairy barns had two rows of cattle on the first floor, with hay storage upstairs. (Source: Plan #5113, circa 1945, USDA Plan Service.)

Hay Mows (Lofts)

Hay mows were located across the central barn floor opposite the animal housing side of the barn and over the cow stable. The hay was stacked from the barn-floor level or below up into the rafters and was divided by the width of the bents and some cross braces. Sometimes vertical boards were attached to the cross braces to more clearly define each bay. Loose hay could stack and settle very tightly and be difficult to pitch out of the mow onto the barn floor. Hay saws were sometimes

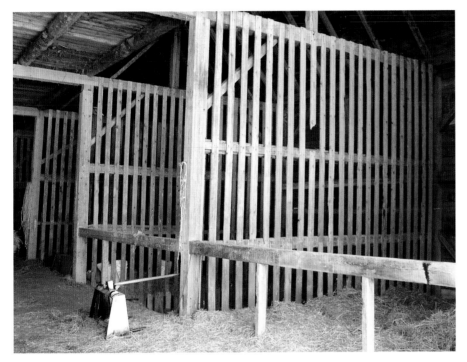

Hay mow dividers to separate hay lofts.

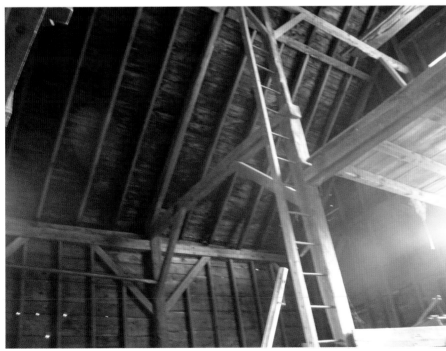

Hay ladder built into the beam for access to the hay mow.

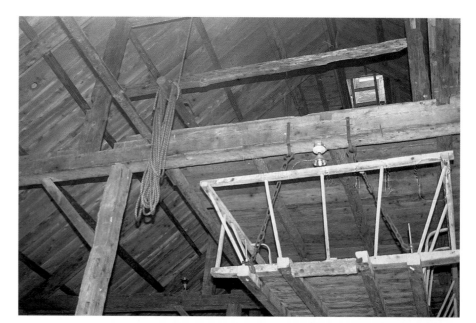

The "flying scaffold" was located above the center drive-through floor and was used for extra hay storage. Often, the hay wagon body was stored under it in the winter time, and the wheels were utilized for other functions such as a dump cart. (Photograph courtesy of Musterfield Farm Museum, North Sutton.)

Hay hole for pitching hay down to the cow stable.

A framework built in the hay mow provides a channel for pitching hay down to the cows.

used to cut apart the entangled hay, so it could be gathered up on a fork. There were often built-in ladders in the hay mow to make it easier to get up and down out of the loft.

Scaffolds (platforms for loose hay storage) were constructed up in the base of the rafters above the central drive floor. Additional hay storage was often provided high above the central barn floor on what was called the "flying scaffold."

In the case of a basement cattle stable, where the cows were housed on the ground floor with the hay mows located on the second floor, provisions would need to be made for a hay hole to pitch the hay down to the cows. Sometimes these were raised, protected chutes with a safety door or an open area surrounded by a frame to provide a channel up through the height of the hay mow for pitching hay down. Signs of whitewash in a second-floor hay mow usually mean the barn had originally been a main floor stable that was moved to the concrete basement level when the public health regulations changed in the 1950s and 1960s stating that cows couldn't be milked on a wooden floor.

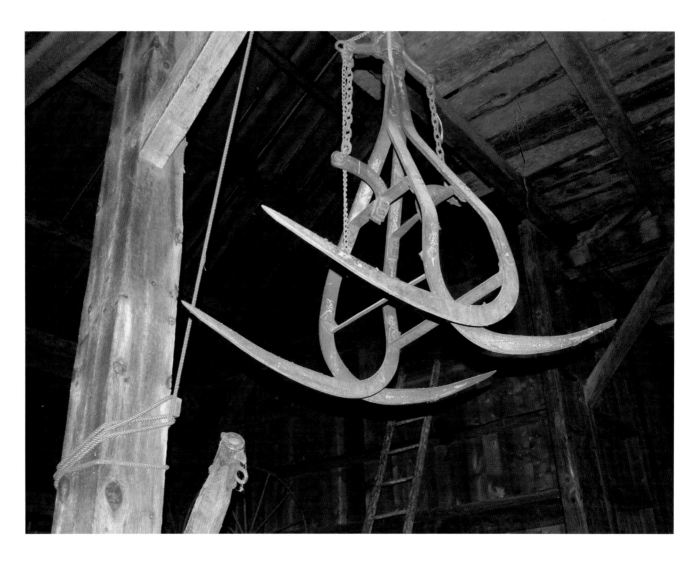

Hay Forks

The advent of the hay fork was a critical development in hay handling. Prior to this, farmers had to hand-pitch hay with a three-tined fork from the hay wagon into the hay loft, and then relay it to other workers who pitched it higher up into the peak of the barn to the top of the mows and scaffold. This was a hot and back-breaking task. The Louden Machinery Company in Fairfield, Iowa, was a leading manufacturer of hay forks, sling carriers, balance grapple forks, and carryall slings. They also made the pulleys and hoists that went with this equipment. They began manufacturing in 1866 and claimed to have sold millions of forks installed in barns throughout the United States.

The balance grapple fork was the most common implement seen on farms. This device had two large forks which grabbed together about

The hay fork was attached to a wheel trolley and pulled along a track.

500-800 pounds of hay as it was lifted by a rope. In the barn, the hay fork and pulley ran along steel, wood, or cable tracks. Sometimes barns had to be renovated or braces removed to accommodate the tracks. With this system, the hay was lifted to the scaffold floor. There was usually a driver with a single horse outside of the barn hitched to a large rope attached to the fork mechanism. The barn crew would shout out directions in order to have the hay fork come to a halt in the right place before pulling a rope to trip the mechanism that dropped the hay on the upper scaffold, and then it would be pitched down into the bays.

The Louden Company also made the power hoist, which had a pulley mechanism that could be

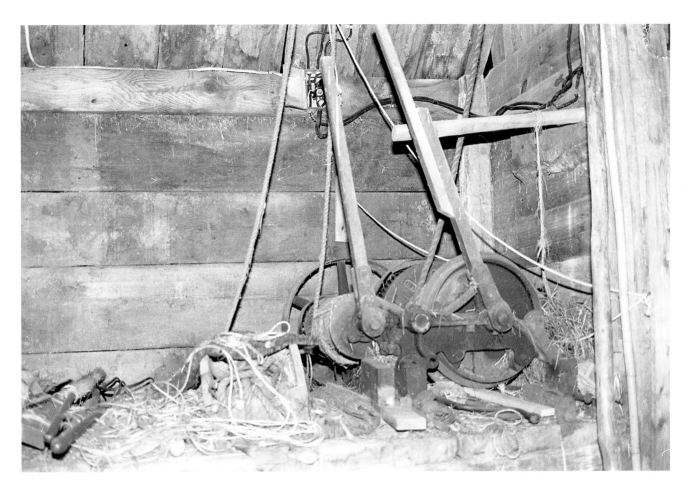

The electric, motorized units could be used to operate the hay fork and eliminated the need for a horse.

operated by steam, gasoline or electric power. This was advertised as being more efficient and saved the labor of an extra man and a horse. This was the main way of mechanizing the hay process up until the 1940s, when field hay balers were developed. Prior to field balers, some baling was done by bringing loose hay to a machine operated at the barn by a stationary engine.

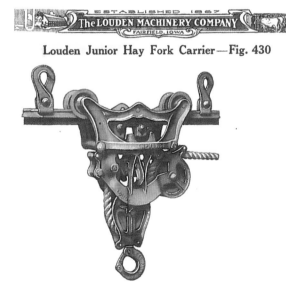

The Louden Machinery Company of Fairfield, Iowa, supplied many of the hay forks. They had trolleys that ran on tracks in the peak of the barn, which were operated by ropes.

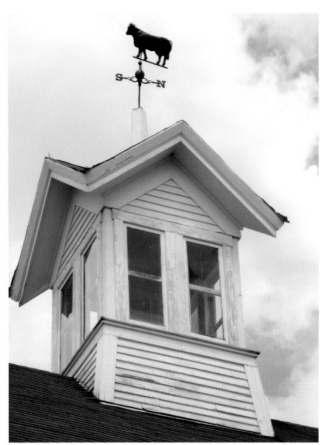

Cupolas can be decorative but were also used for ventilation. (Photograph by Lowell Fewster.)

Ventilation

Cupolas

As barns got larger and housed more animals, ventilation increasingly became an issue. Prior to this, the natural air cracks and opened windows in small buildings helped to maintain air quality. When wooden shingles and clapboards were added to barn exteriors to dress them up, it also made the barns tighter. In addition to the cosmetic changes to the barns, farmers were milking more cows and the gases from the cows breathing, belching, and making manure caused poor air quality issues in the stable. This resulted in strong ammonia odors, which could affect milk flavor and animal health, as well as causing moisture build-up and condensation on the walls and ceiling.

Many of the large, Yankee barns of the 1850s and later had cupolas located in the center of the roof on the ridge pole. These could be ornate, and people often appreciate them for beauty and

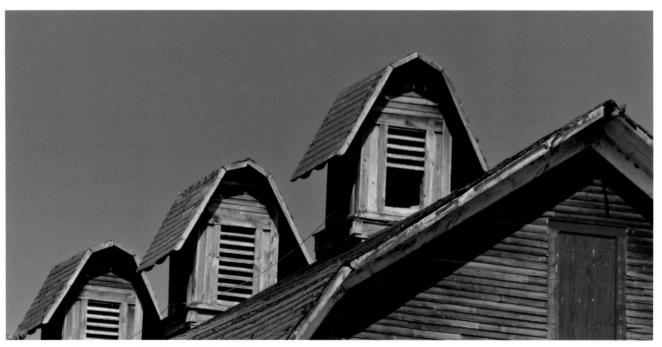

Several cupolas were needed to ventilate a large barn. (Photograph by Lowell Fewster.)

style; however, they were also very functional in the ventilation process. These cupolas were open over the hay mow and had a series of ladders leading up to them from the barn floor. They are often thought of as vents for the hay stacked in the hay mow. This is true, since even dry hay still gives off a little moisture as it cures in the barn; however, many cupolas were also connected to the cattle stables where they helped to remove the animal gases and excess moisture.

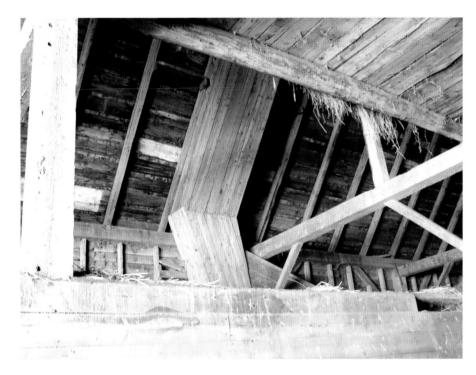

Ventilation channel, which carries the cow stable exhaust air up to the cupola.

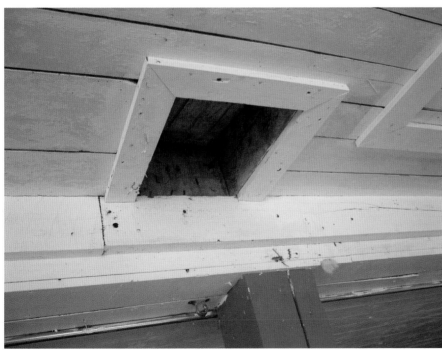

Ceiling opening, which connects the ventilation duct to the cow stable.

Cupolas that also ventilated stables had enclosed wooden channels which were positioned between the rafters and down the side of the building to the stable ceiling. The ceiling vents could be opened to remove the stale air from the animal areas. This worked in a chimney effect, drawing the air to the top and out the cupola. Some of the newer barns of the 1940s and 1950s had fabricated, metal ventilators which replaced the ornate cupolas. These were connected to elaborate tube duct systems and were sometimes supplemented with electric fans. Companies such as Sears and Roebuck and Jamesway sold these packaged systems.

As cattle herds grew, this natural form of ventilation was abandoned, and electrical fans were used to ventilate stables by positioning exhaust fans around the perimeter of the stable and pulling fresh air in through controlled inlets. Later research showed that increasing the number of cupolas on a roof would make them more effective, and natural ventilation became more popular in barns during the energy crisis of the 1970s.

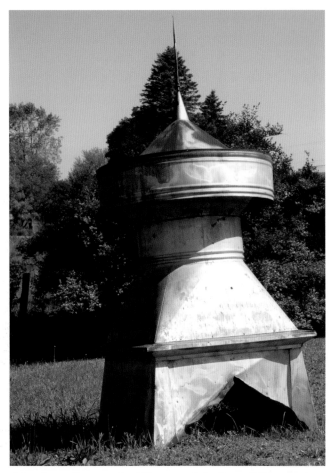

Metal ventilator unit. (Photograph by Lowell Fewster.)

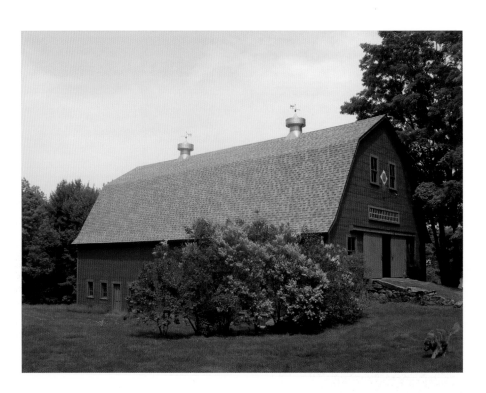

Metal ventilators on the barn roof. (Photograph by Beverly Thomas.)

Accessory Features

The heading of "accessory features" is a broad category to cover many of the features found in barns. There are many specialized features that speak to the barn's use, topography surrounding it and either the builder's or farmer's ingenuity.

Stairways

Stairways in barns are typically very steep, narrow and dark. This is because space was very much at a premium in a barn, and builders didn't want to waste a lot of area constructing stairs. Generally, there were stairs leading to the basement; going up to the second floor; and a series winding their way up to the cupola. A steep rise over the run meant the stairs didn't take up a lot of space, and they were at a sharp angle and often had narrow treads. To make good use of space, there were sometimes storage cupboards under the stairs for hand tools. In the early days, a lantern would be carried up the steps, and with the advent of electricity, there might be a little, dim bulb lighting the way.

Narrow stairways often provided access to the basement.

A series of narrow, internal stairways often led to the cupola.

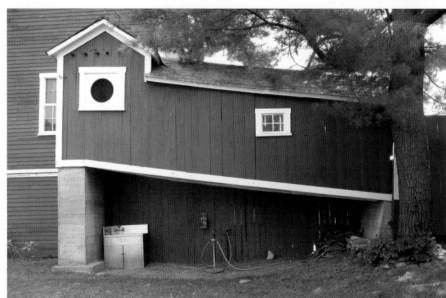

Animal ramps were either left open or covered and provided a way for the animals to enter the barn.

Animal Ramps

The entries to old barns were often higher than the ground level due to the topography of the land, height of the foundation and support sill, or general erosion of the ground due to animal traffic. A common solution was one or two large granite steps placed at the entry door. Cattle can handle a series of steps if they are wide and of reasonable height.

If there was a large elevation difference or a need to link between buildings, a covered ramp was used. These were not too wide, so the

cows would enter single file and not crowd one another, and sometimes had windows to let in some natural light. Granite blocks were often placed at the entry, which led to a wooden ramp with cross pieces every foot or so to keep the animals from slipping. New heifers often spooked at ramps, but once animals were accustomed to them, they proceeded into the barn very methodically.

Another type of ramp is the internal barn ramp, which took the animals from the basement to the upstairs stable. These ramps were generally a long series of granite blocks either stacked in succession to create a stairway, or a series of short rock walls which served as retainers and were filled with packed gravel to form broad steps. In the length of fifteen to twenty feet, a one-thousand-pound cow could climb an elevation of eight feet or more from the basement to the next floor. The internal ramp could be positioned in the center of the barn and open to both sides of the stable, or be located at one end.

In the summer, the cows went out to pasture in the morning after milking, returned at night for milking, and then went out again to a night pasture. In the winter, the cows were confined inside but left the barn morning and night to get water. There was no running water in these old barns, and the cows got just two chances a day to get a drink. They would either exit out of an upstairs door to go to the barnyard where there would be a water trough or go down through the internal barn ramp to a trough in the basement or a lower-level barnyard. Some earlier internal plumbing systems had a gravity-filled tub on the second floor which supplied water bowls down below in the stable. Running water in the barns became more common after the 1930s, when electricity was available for operating mechanical pumps.

Animal stairways within the barn created an access from the basement to the first floor stable.

Silos

Early systems of making silage or "ensilage" were patterned after the subterranean units used by the Romans and Native American Indians to create vaults for storing fruits, grain, and forage. Some of these were built around New England in the 1870s and were large, rectangular structures made of concrete sunk about half way below the earth's surface, and sometimes covered with a roof. These preserved the wet feed by fermentation and provided excellent quality feed throughout the winter (Bailey 1881, 11–23). Such a large, concrete bunker remains in the woods in the Quinttown section of Orford. These units were somewhat cumbersome to load and unload with limited forage cutters and only hand equipment.

Vertical silos started to come into use around the 1880s when animal researchers at the land grant universities started experimenting with fermented feeds. They promoted the idea of cutting grass or corn green, chopping it and preserving it in a fermented state in sort of a pickling process. The limitation to this procedure on a lot of farms was the machinery required to chop and elevate the feed up into the top of the silo. This was first done by stationary cutter-blowers powered by an engine or a conveyor by the silo. Later, there were field choppers pulled in the field by a tractor, and the chopped feed was brought in wagons and trucks to centrifugal blowers.

In the late 1800s, wooden silos were constructed within the barn and were square in shape because of the lack of technology for milling beveled, rounded lumber to form a circular structure. Evidence of these early silos can be found under wooden barn floors where there are built-up rock foundations and outside dormer windows on the roof for filling. Keeping silos inside the barn helped to minimize the problem of feed freezing in the square corners. Later, round silos were built inside of barns, but these displaced hay storage space. By the turn of twentieth century, farmers began constructing free-standing octagonal silos outside of the barn. Eventually, the technology was developed to mill angled tongue-and-groove lumber to create tight, round silos that could stand

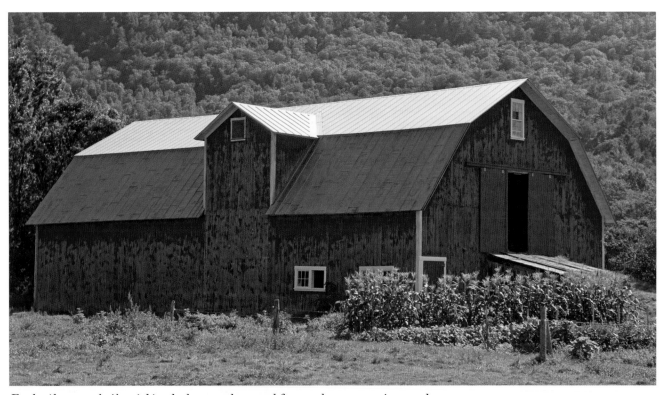

Early silos were built within the barn and accessed from a dormer opening on the outside. This barn is located on Plains Road in Monroe. (Photograph by Lowell Fewster.)

Silos were later built outside of the barn, but constructed multi-sided. (Photograph by Lowell Fewster.)

outside and have minimal freezing problems in the winter. By 1910, a few farmers were building silos of glazed, hollow, terra-cotta blocks. By the 1920s, silos constructed of hooped-bound concrete staves were becoming popular. Silos of glass-coated steel became increasingly common after World War II. There were several old companies that continued to manufacture wooden silos even after some of these other types of silos were introduced. These companies included the Craine Silo Company in Norwich, New York, and Unadilla Silo Company in Unadilla, New York.

It was preferable to have the silos located along the side of the barn to leave the barn ends open for expansion. Silos were typically connected to the barn with a short feed room, which provided space for a feed cart to be parked at the base of the silo. The feed was pitched out of the small doors in the side of the silo, which were removed as the level of silage lowered, and then systematically put into place as the silo was filled.

It is ironic that silos today have evolved back to the horizontal, concrete-bunker design, as they are quicker to load and unload than a vertical silo and can be built for greater storage capacities.

When milling technology improved, round silos were made with grooved lumber and built outside of the barn. (Photograph by Lowell Fewster.)

RIGHT: *These silos were built to share a common roof and unloading chute. (Photograph by Lowell Fewster.)*

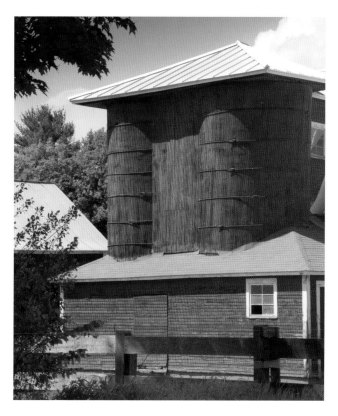

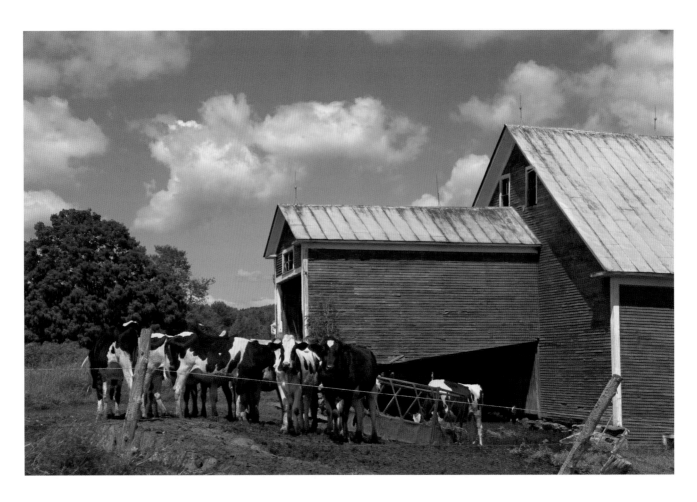

Barn bridge leading to second-floor hay mow. (Photograph by Lowell Fewster.)

Barn Bridges

To enter a barn built on a high elevation or into the side of a bank, a type of ramp was needed to drive the horses and wagon in to unload the hay. Usually there was a corresponding ramp on the opposite end, so teams could be driven straight through, but sometimes the team had to be backed out. A simple, open ramp was often called a wharfin, which, like a lot of barn parts, was taken from naval terminology. This ramp consisted of several large timbers closely spaced and spanning from the ground to the building, which was then then covered with thick planks.

Many of these ramps, which led to the high drives up in the peak of the barn, were covered and called barn bridges. The ramps were protected from the weather with vertically boarded sides and a roof like a small covered bridge. Some were quite long because there was a lot of slope between the ground level and the barn entrance.

High Drives

The high drive was a rugged, supported floor structure with railings that was entered from the barn bridge. The high drive extended the length of the barn and was raised above the hay mow floor, so the hay could be pitched down to take advantage of gravity, making the top of the hay pile above the high drive floor more in line with the height of the hay wagon for easier unloading. Usually the high drive didn't have an exit on the far end, and so the team of horses would have to be backed out after unloading. This design feature tended to pre-date the hay fork, because with that technology, the hay could be mechanically lifted into the barn and dropped into place.

The high drive created an empty, low cavity underneath its floor, with hay mows on each side. This space sometimes contained a large water tub which was gravity-fed from water running through a pipe from a distant well that then supplied the barn.

The space under the high drive also served as a feed access area, where hay might be pulled in from the adjoining hay mows and pitched down a hay hole to feed the cattle. Occasionally there were bulk grain bins located in that space which could be filled from holes in the high drive floor. Hopper doors in the first-floor ceiling were at the base of the bins for filling grain carts at the stable level.

Windlasses

The windlass is a large wheel that uses mechanical advantage to lift heavy objects. Once again this is a nautical term applied to barns. These were found in various designs and sizes and usually located at the end of the barn, over the barn floor by a large entry door. A windlass could be something as elaborate as a six-to-eight-foot-diameter wheel

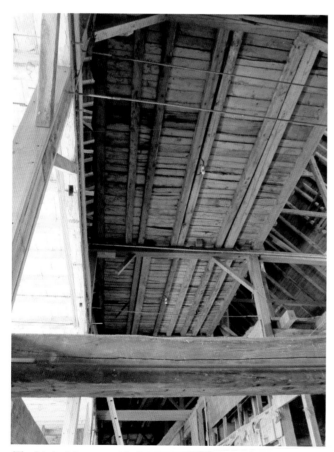

The high drive provided access near the top of the barn so hay could be pitched down into the hay mow. (Photograph by Lowell Fewster.)

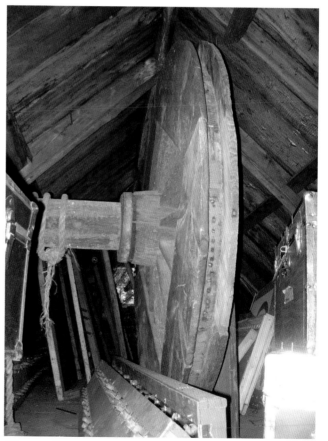

The windlass is a nautical term for a wheel with a horizontal shaft and ropes used to lift things. (Photograph by Beverly Thomas.)

operating a rope, or as simple as a long pole with short peg handles for manual turning. If there was no windlass, there was often just a pole running high over the barn floor from beam to beam in front of the door and pulley blocks were hooked to it for lifting.

Generally, the windlass mechanism was used for raising a carcass off the barn floor and suspending it for butchering. This was usually done in the late fall, so the meat could remain hanging and age in the barn for several days. The windlass could also be used to lift heavy objects out of a wagon, or to assist in removing hay wagon and dump cart bodies from their respective wheel bases to interchange them for each season.

Grain Boxes

Grain boxes were often a built-in feature in a barn. They were used to store the concentrate feed that was typically fed to dairy cows. In the early days, farms in New England raised their own grains and mixed what was called a grist, which was made up of wheat, dry shelled corn, soybeans, barley, and whatever grains the farm produced, along with some minerals and molasses. Later as Western grains became available in ample quantities, farmers bought commercial dairy rations in one-hundred-pound burlap bags.

The bagged grain was often dumped directly into buckets or feed carts for distribution to the cattle, but the grist was made in batches and stored in the grain boxes. These characteristically exhibit super smooth sides from years of grain being poured over the edges. Sometimes there were divisions within the box for various types of grains or supplements. The smell of the grain often permeated the barn with the sweet odor of the minerals and molasses.

The grain boxes were sometimes located in the cow stable part of the barn, and other times on the edge of the hay mow on the center barn floor. The top of the box was on hinges and the cover was lifted and leaned back to gain access to the feed. Usually it was easier to open the feed doors in front of the cows by the center barn floor and pour the correct amount of grain in front of each cow, rather than enter the tie-up area from behind.

Grain boxes were sometimes built into corners or small rooms for storing grist or grain.

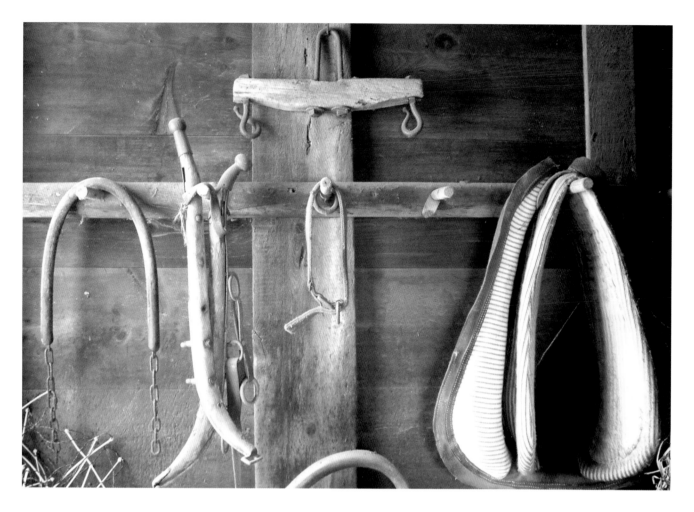

Hanging Hooks

Most everything in old barns had a purpose, and it is interesting to look over a barn and imagine how things functioned when it was in full operation. One simple thing that can be observed is the location of hanging hooks in a barn. Sometimes these were long, forged or cut nails, or round pegs driven into a beam on an angle.

One thing that often hung in a prominent place was the milk stool. This and the milk pail were the first things grabbed when the farmer entered the barn to start milking. The milk stool might have solid sides and a seat, three round legs or be metal with curved metal base, but there was usually a leather, looped strap on one side for hanging it up. Another hook might be for the farmer's overalls. Some farmers had a ritual of wearing special clothing and caps for milking. The bib overalls had a lot of pockets and pouches

Hooks and pegs were often strategically placed around the barn for hanging things.

where little tools and animal treatment remedies could be kept.

In the early days, most farms had a breeding bull, and it was common to have a bull rod for handling the bull. This was a long, metal rod with a hook on one end to attach to the bull's nose ring and a trigger on the other end for releasing it. This rod usually hung on a hook ready to be put into use. Also, there was often a rope halter for moving cows or taming young heifers. Then there might be other hooks for horse harnesses, bridles, collars, and other useful farm implements.

Storage cabinets were attached to the sidewalls of the barn to contain home remedies and cattle supplies.

Storage Cabinets

Nearly every barn had some type of storage cabinet in the stable area. Finding one of these can provide a wealth of information about the farming operation. One primary piece of information usually attached to the inside of the cabinet door was the breeding record chart. This contained the names and the breeding dates of cows, who they were bred to and when, the birth date of the calf, the sex and name of the calf, and other details.

Crop records were also often scribbled on the back side of the cabinet. Farmers sometimes used a series of four lines with a hatch mark through them showing increments of five bushels, loads, or pounds of some crop. There might be a date and a separation line between the years.

Something else found in old storage cabinets can be remnants of old animal drug treatments. Things like Bag Balm, horse liniment, disinfectants, bleach, teat dilators, aspirin, boluses, and herbal remedies were among the farmer's arsenal of medicines before antibiotics became available to treat animals for various aches, pains, and infections.

There could also be an assortment of small tools and instruments to take care of something in a hurry. Perhaps you might find a hammer and pair of pliers for a quick fix-it project, a nose-lead for handling an unruly heifer, a bolus gun for giving large pills, a drenching gun for administering liquids, various hoof trimming knives and rasps, or a graduated weight-tape for estimating an animal's weight by measuring them around the heart girth.

Outhouses were sometimes located in a connector link or front corner of the barn.

Outhouses

The mention of outhouses in a barn always gets a few snickers and speculation as to how fast the trips were made there and back in cold weather. Because of distance, most outhouses were located in the back shed of the house or a connector link leading to the barn. However, if the barn was close by, it might be located in the front corner of the barn. In the case where most elements of an outhouse have been removed, telltale signs of one's prior existence are shellacked, finished lumber or plaster walls in an area; a small window up high on the outside wall; a clean-out door at the basement level; and possibly a vent leading out to an exterior wall.

Outhouses are often classified as one-holers, two-holers, or three-holers, and people often chuckle at the sight of two or three seats in an outhouse, and they can't imagine several people being there at once. The practicality of this is probably that as the winter went on, things piled up under one seat and you then moved along to the next one until things got cleaned out in the spring. Folklore has it that the men's room usually had a star or sunburst, and the ladies room had the half moon, although on the farm everyone usually shared the same unit. Stories are true about corn cobs and old catalog pages being used prior to the introduction of toilet paper.

Barn Modifications

Structural Alterations

It is not uncommon to see modifications made to an original barn structure. From time to time this was done to add structural integrity. As barns age, they can shift on their foundations and joints open and the frame starts to pull apart. It is important to catch these issues early and take corrective action. Although not pretty, sometimes the solution is to add cables or metal rods to tie things together. The cables are run across the width of the barn in several places and fastened to the outside of the barn wall with a threaded hook anchored in a large wooden or metal washer. The cables are tightened in the middle with a turnbuckle. Metal rods can be run along existing beams in order to

Rods or trusses attached over the second floor were sometimes used to support the ceiling and allow internal posts to be removed below.

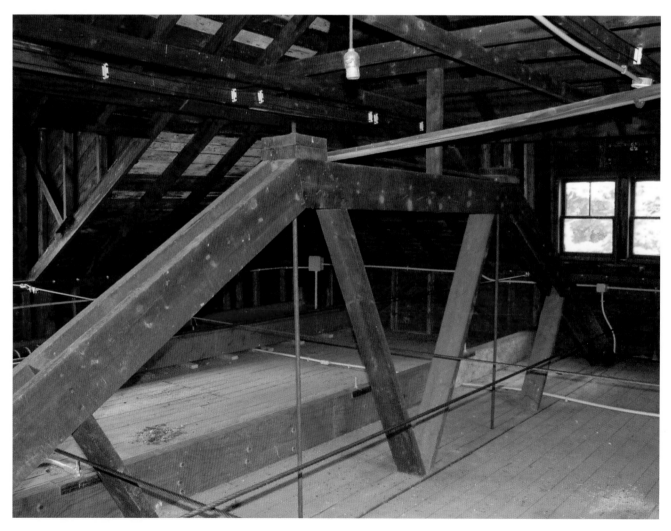

be not so obtrusive as cables, then also fastened to the outside wall of the building and tightened with large nuts or turnbuckles. Metal plates are often added to strengthen joints or lumber attached to the sides of weakened timbers, but this should be done in a way that doesn't detract from the building.

As agriculture changed through the years, barns were modified to adopt new technology and uses. The hay fork was mentioned earlier, and when that was added to some barns, braces that were in the way had to be moved and new ones added off to the side. These old barns were generally built in twelve-foot bents or sections, so there was a post twelve feet in any direction, which often got in the way. There were booklets published on how to improve the efficiency of old barns and safely remove some posts to make space more useable.

One method used for supporting floors when the posts were removed was the internal truss. Large beams were built on angles in a bridge-like fashion with internal web bracing to create a structure above the ceiling which could support downward weight pressure. These units were built across the barn in intervals where the posts existed and extended to the outside support walls; then large, iron rods were fastened to the top of the truss and run down through the bracing and fastened on the bottom with a large nut and washer to a carrying beam. The post below could then be removed, and the truss supported the weight. This was done especially in barns converted to livery stables, as it allowed a horse and buggy to enter and turn to be hitched or unhitched.

Some old barns were originally built with the internal truss system so a basement or first floor could be free of posts. This meant that several large, iron rods extended down from the rafter and beam structures and were fastened to the ceiling below. This could create a large open basement or ground floor space where horses and wagons could enter and turn to haul out manure or other stored products.

Moving and Extending Existing Structures

It was not uncommon for barns to be expanded in size. In the early days, the New England landscape featured small English barns, which were originally designed for subsistence farming. As agricultural production grew, more room was needed for animals and crop storage. Often, existing barns were used for materials in new barns, because this saved the farmer having to go into the woods and cut down trees and hew them into beams. An indication of re-used lumber in a barn is the appearance of beams with existing notches that don't line up with anything.

If it was close enough, one barn might be moved intact like a box and added to another existing barn. Without electrical wires, there were fewer hindrances, and barns could be moved on rollers or on skids in the winter. With an English barn, the addition was usually added to the end, so there would be a second set of doors under the eaves, making it a "double-English" barn. More commonly, a barn might be dismantled, and the parts labeled with Roman numerals, so the joints could be properly reassembled.

Yankee barns were usually extended on the gable ends. An addition can be detected on these barns by examining the last section or bent and seeing if the major beams butt up against the main structure rather than being notched. Another indication is a change in architectural style in the beams, roof boards, or construction. If the original barn had a cupola, an addition would put that off-center.

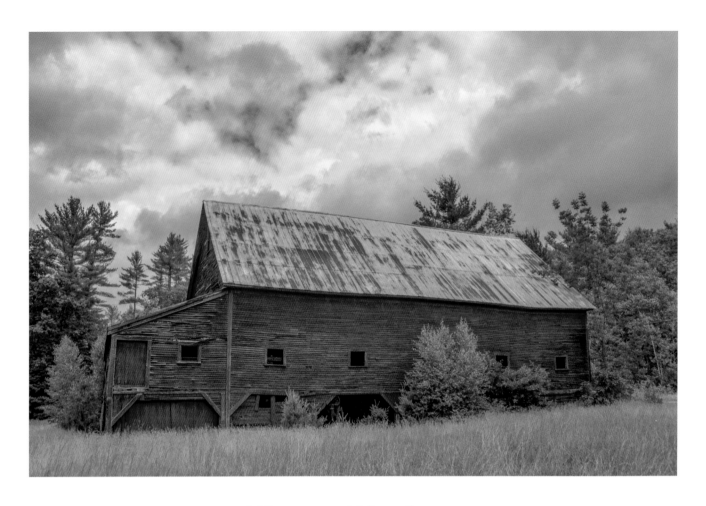

A common landmark in the Concord area known as the "red barn" is located at the intersection of Horsehill and Warner Roads. It was originally part of the old Bennett Farm and was built in the late 1800s. This is an example of a gable-end barn with an addition on one end to add more space for animal housing. (Photograph by Lowell Fewster.)

Additions and New Construction

As agricultural operations continued to expand in the late 1800s and early 1900s, new additions were added primarily to Yankee barns, which were the most common design used after the 1850s. One typical addition was a lean-to off the back, gable end. This was often a one-slope roof extending out to a wall. A lean-to addition was generally intended to add more space for replacement heifers for a growing dairy operation. These were often about fifteen feet wide, which allowed for a single row of cattle and provided space for a feed manger, cow standing platform, gutter, and walkway.

Some Yankee barn additions were off from the side of the barn and would either follow the slope of the roof or have a slight change of pitch if the side wall had limited height. A modified pitch could create a weak link in the construction, as snow can accumulate at the juncture of the two roofs and cause structural failure. These side additions were sometimes left open for hay or equipment storage or closed in to add another row of cattle in the stable.

A high percentage of old barns were used to house dairy cattle. Originally, farmers turned their milk into butter, which was a more marketable and less perishable product than fresh milk to sell to the cities;

but as the population grew, demand for fluid milk increased. Public health regulations required a milk house for straining and cooling milk and washing the milking utensils. At first, regulations required the milk house be built separate from the barn to avoid manure contamination. However, that did not eliminate the concern about the contamination from dirt and flies getting into open pails carried between the barn and milk house. The rule was changed so that the milk house could be attached to the barn if there was a vestibule with double swinging doors to create an air lock between the buildings. The U.S. Department of Agriculture published many plans for milk houses, and later these were expanded to accommodate the replacement of can coolers with bulk tanks in the 1950s.

Early milk rooms were separate from the barns and later attached with a vestibule between the barn and the milk room with two doors.

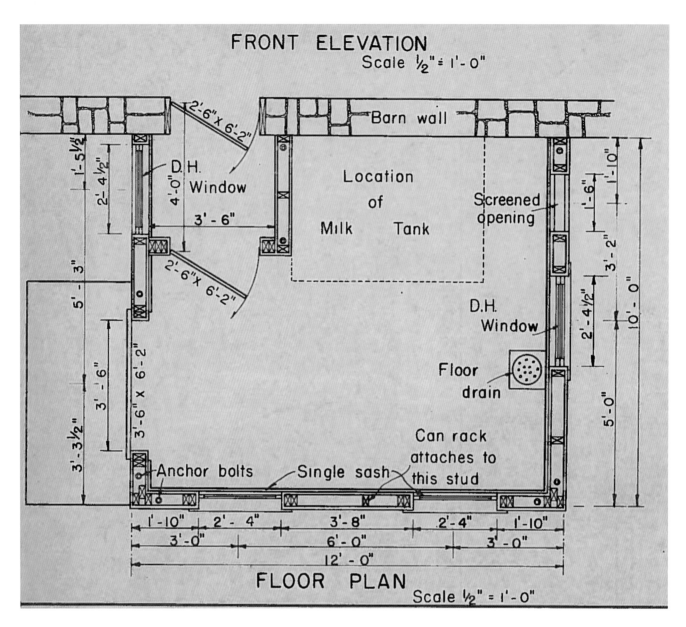

There were several standard plans for building milk rooms that met the needs of a growing dairy industry. (Source: Plan #5154, circa 1940, USDA Plan Service.)

Preserved Barns

The following section of color photos gives many examples of preserved barns in New Hampshire. Some of the projects cost several thousand dollars and restored the structure to beautiful condition, while others were more modest and dealt with basic structural features such as foundations, support beams, and roofs. Regardless, in each case a barn was preserved and is still standing to maintain the scenery and character of rural New Hampshire.

The Langwood Barn in Cornish dates from the early 1800s. This double English barn consists of two connected barns, which were likely sitting separately in nearby fields at one time. The western-most section is a typical 30' x 40' English barn built around 1820. The attached longer section was likely another 30' x 40' barn from the 1840s–1850s with an extended 10' portion. Probably both barns were moved to the site together in the late 1800s and perched on a new stone foundation and basement section. In 1931, concrete was poured in the lower barn to construct a dairy stable approved by public health. A major renovation to this barn was done in 2008 to jack it up and replace rotted posts and flooring, install a new roof, and make foundation repairs; so it is now preserved for future generations. (Photograph by Lowell Fewster.)

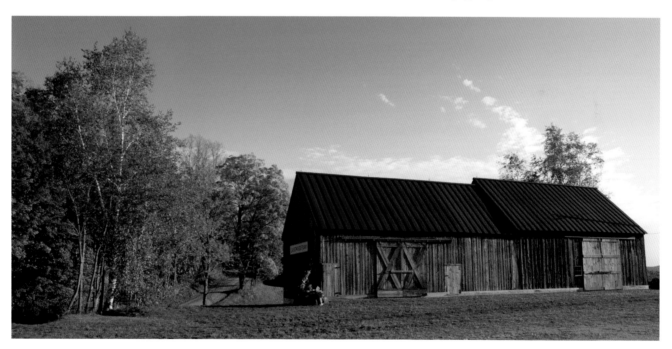

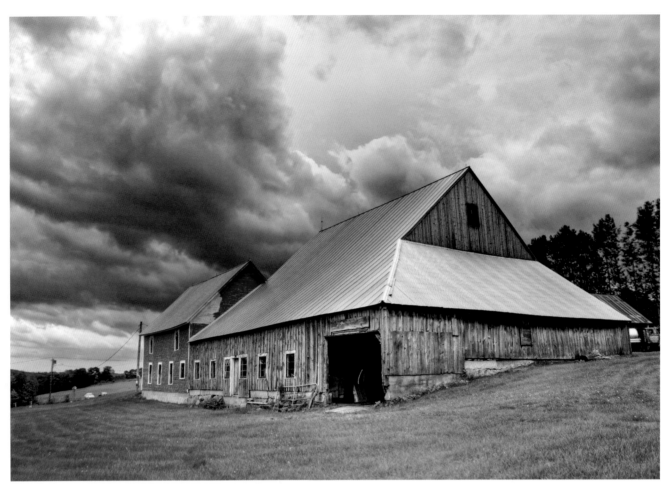

The main barn was built by Nathaniel Storrs in about 1800 on Storrs Hill in Lebanon. An addition to the original barn was built in the late 1800s or early 1900s, creating this sprawling complex of barns. The original English barn was built on split granite rock. The barns were used for housing dairy cattle and storing hay. The side boards located inside on the edges of the central barn floor contained the grain, which was separated from the straw stems during the threshing process. (Photograph by Lowell Fewster.)

This stone barn in Newbury, originally part of the Fells summer estate, encompassed nearly one thousand acres. The property was acquired by John Milton Hay (Secretary of State and biographer of Lincoln) starting in 1888, and later named The Fells in reference to the rugged landscapes characteristic of Scotland. Hay hired architect George Hammond to design the gambrel-roofed house (1891) and, later, the barn was built from stone in a similar design. (Photograph by Lowell Fewster.)

This picturesque barn at Riverfields Farm is visible from Route 12-A outside of Claremont. It is a high-drive barn built in the late 1800s and is about 42' x 100'. The owners have maintained it in good repair with roof replacements, clapboard repairs, and painting. It has a unique barn bridge incorporated into an addition on the back of the barn. It is of historical significance in the area, and a historical marker verifies that in 1825, while traveling from Boston on tour, General Lafayette of France came there and partook of wine at the farm. (Photograph by Lowell Fewster.)

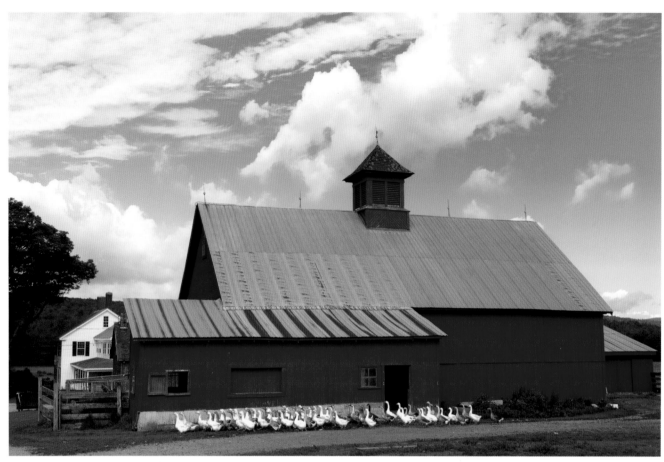

Sanctuary Farm is an operating dairy farm in the village of Wendell on the edge of Sunapee, visible from Route 103 outside of Newport. The farm property has been in the family since the mid-1700s. The old barns were built in 1920 and now complement a newer facility built in 1987 to accommodate fifty head of milking cows. The new barn is naturally ventilated using an updated version of the cupola ventilation system used in the old barns. (Photograph by Lowell Fewster.)

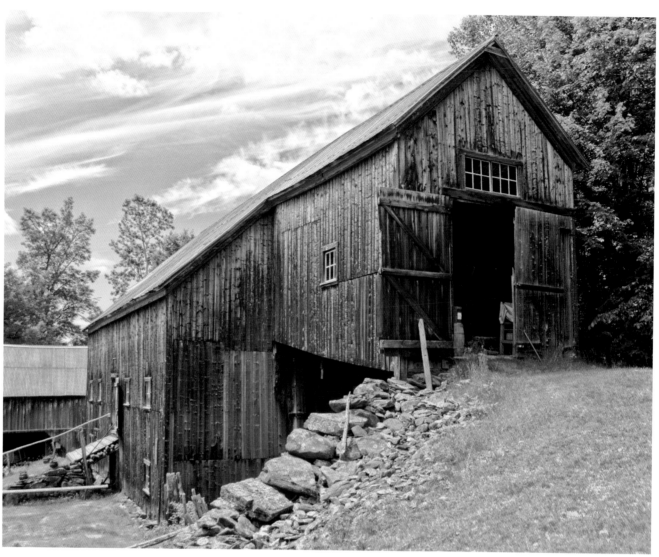

The Poore Farm is a museum in Stewartstown along Route 145, maintained by the Poore Family Foundation for North Country Conservancy. It was bequeathed to them in 1983 by John Calvin Kenneth Poore, the last family descendant. The barn was built in about 1850, and the homestead is used to portray family life from the 1830s to the 1980s. The barn has one of the longest barn bridges in the state, which covers a ramp leading to a high-drive floor that runs the length of the barn. The barn is an excellent example of barn architecture of that time and is filled with a large collection of artifacts and old farm equipment. (Photograph by Lowell Fewster.)

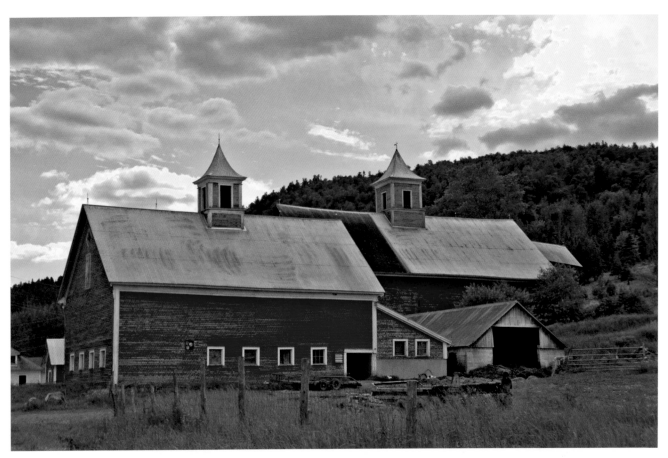

The Amey Farm is one of the northern-most operating farms in New Hampshire and is located on Tabor Road in Pittsburg. The farm utilized the old barns to house the dairy cows prior to dispersing the herd in 2018. Built in the 1880s, the smaller of the two barns was a horse barn, and it was also used to store equipment. The larger barn was built for about twenty cows in one string upstairs, with manure storage underneath. A more recent cow stable was attached on one end, which allowed for the expansion of the herd and the addition of newer barn technology, such as a milking pipeline and gutter cleaner. (Photograph by Lowell Fewster.)

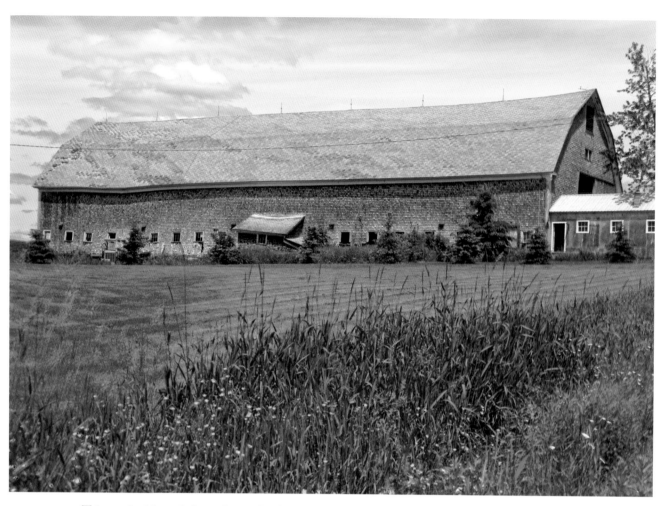

This gambrel barn is located outside of Colebrook on Diamond Pond Road. It is one of the largest barns in the state built of this vintage with a high drive. It was constructed in 1918 and is 50' wide x 180' long. (Photograph by Lowell Fewster.)

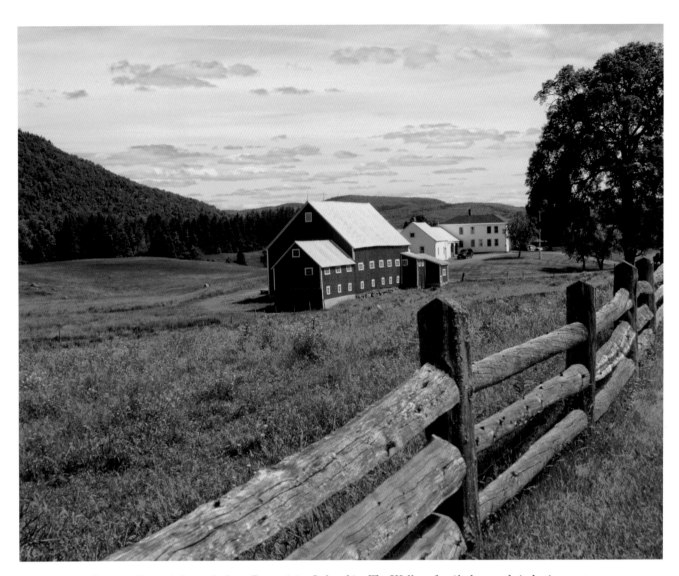

Pioneer Farm is located along Route 3 in Columbia. The Wallace family began their heritage at the farm in 1785 when the Wallace brothers cleared the land and built a log cabin. There is an old horse barn built circa 1835, and the main dairy barn was constructed in the early 1900s, with additions in 1928 and 1940 to accommodate a growing dairy herd. The farmhouse was added to the National Register of Historic Places in 2001. Robert K. Young, widower of Ione Jane Wallace, joined forces with Ruby Wallace in 2008 and set out to come up with a plan that would preserve the Pioneer Farm, which had fallen into disrepair. The Pioneer Farm Educational Center Trust was awarded charitable status dedicated to providing education and training, and to equip interested individuals with the basic skills of country living. The barn is an icon in the North Country. (Photograph by Lowell Fewster.)

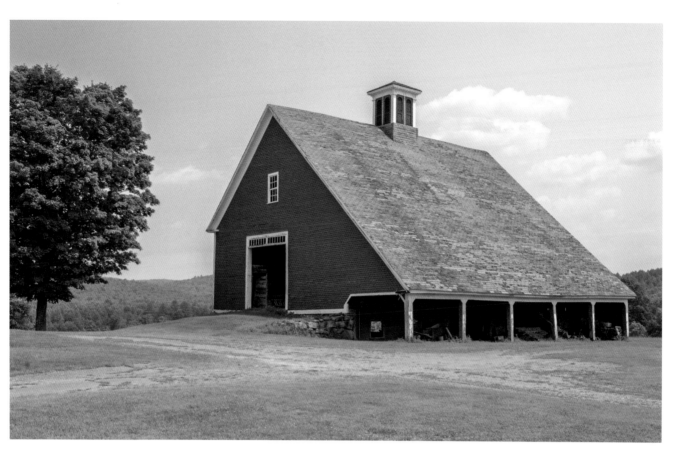

This barn in Westmoreland is located on a knoll overlooking a valley. It has a unique lean-to on one side which blends smoothly with the roofline. It is not known whether this was an original part of the barn or added later. In early records it was listed as a woodshed and more recently has been used for equipment storage. (Photograph by Lowell Fewster.)

This is the farmstead where the author, John Porter, grew up on Stevens Road in Lebanon. It is one of the largest complexes of attached barns in the Upper Valley. The center barn is an English barn built in the early 1800s; then a Yankee barn on the right, around the 1850s; and on the left, a large barn built in the 1920s over an existing horse barn. There was also quite a cluster of outbuildings, including a corn barn, water house, and the hen house shown in front. (Photograph by Lowell Fewster.)

This large, red barn with the ornate cupola on Main Street in Chichester was known as the Langmaid Farm. In the most recent years, it was beautifully maintained by Barbara Frangione, and it is enjoyed daily by the large numbers of commuters who pass by it on the shortcut through Chichester village. (Photograph by Lowell Fewster.)

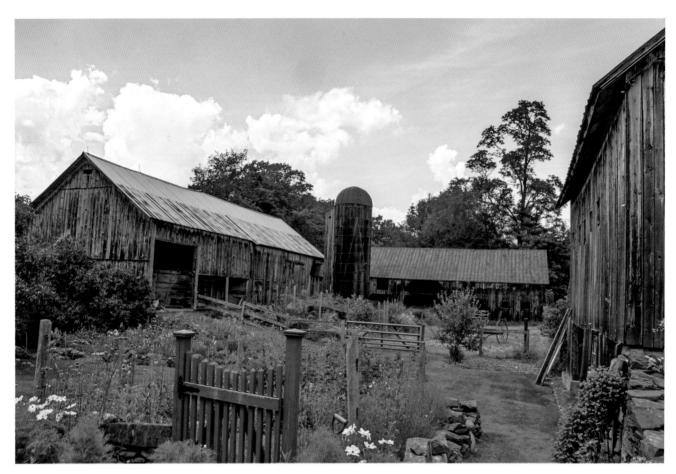

Nestled on River Road in Lyme is this classic farmstead from about the 1850s. It consists of a dairy barn in the foreground, heifer barn across the back, and a horse barn on the right. Remnants of the old cattle and horse tie-ups are still evident in the structures. (Photograph by Lowell Fewster.)

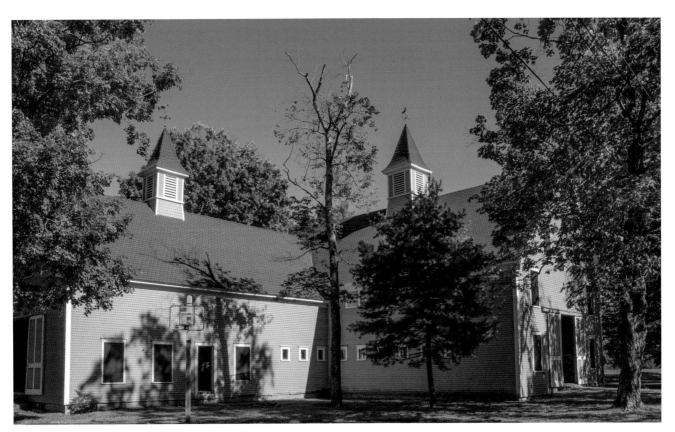

This historic barn is an integral part of the former estate property known as Windermere, located at the tip of Moultonborough's Long Island. Designed by Boston architect J. H. Besarick for Dr. Frank Eugene Greene, Windermere was one of the town's earliest summer estates, built in 1891–1892. One section of the L-shaped barn is a stable for ten horses (with carriage room and hayloft), while the other is a cow barn (with stanchions for ten cows, two pens, and a hayloft). The estate barn retains most of its original features, including a wooden water tank at its peak. (Photograph by Lowell Fewster.)

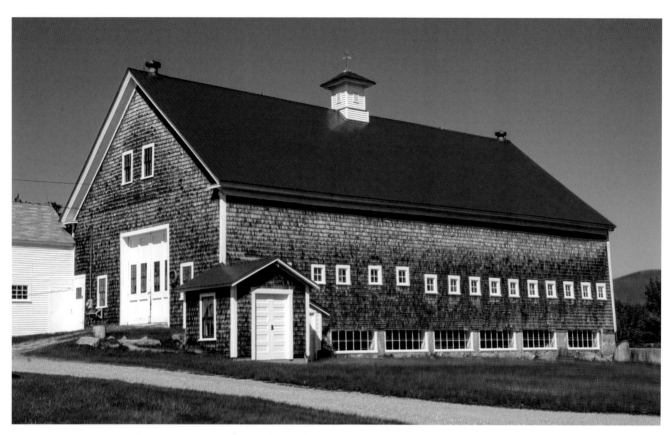

The historic Hollingsworth Farm on Moultonborough Neck has been an integral part of Camp Tecumseh (founded 1903) since 1920, when the 250-acre working farm was added to the expanding camp property on Lake Winnipesaukee. In the early years, Camp Tecumseh was a self-sufficient agricultural enterprise, where campers helped with farming chores (garden, livestock). By 1920, the camp owned twenty dairy cows and a bull. Today, the connected farm compound (farmhouse and barn) provides housing for camp staff, and the barn is outfitted as an indoor activity facility. (Photograph by Lowell Fewster.)

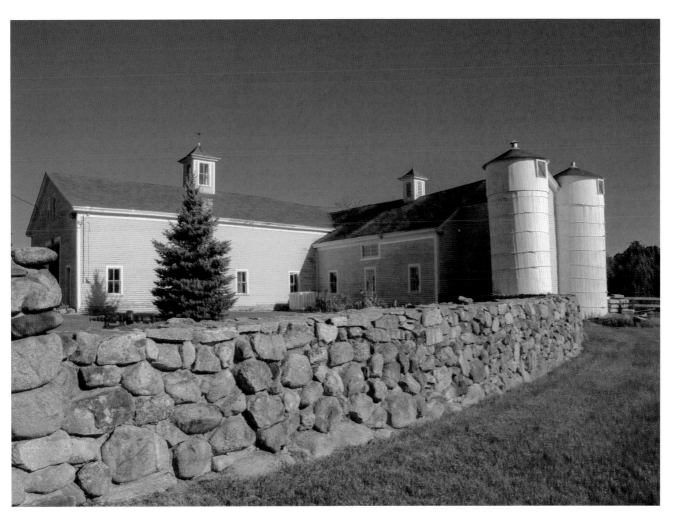

Historic Sheridan Farm (later Red Hill Farm) in Moultonborough was the summer estate of attorney Thomas Sheridan of Chicago in the early twentieth century, with about eight hundred acres of pasture and woodland at the time of its sale in the early 1930s. The estate barn housed thoroughbred Morgan horses, Southdown sheep, Chester White swine, and Devon cattle in its heyday (later registered Guernseys). The barn still has two remaining upright silos, an adjacent milk room, and an intact medicine cabinet listing dairy cow names in its interior. The valley farm is a community landmark. (Photograph by Lowell Fewster.)

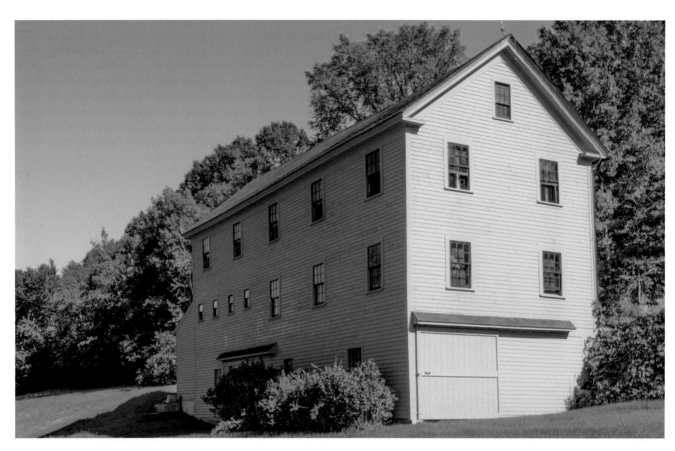

Cotton Farm is located on Bean Road in Moultonborough, overlooking Squam Lake. The side-hill barn once housed horses and chickens, and this was the first barn in Moultonborough to participate in the statewide RSA 79-D barn easement program. The property was purchased as a summer place in 1919, one of a number of area farms contributing to the "New Hampshire Farms for Summer Homes" initiative promoted by the state Board of Agriculture in the early twentieth century. Historic Cotton Farm is also described and illustrated in Rachel Carley's book Squam *(2004). (Photograph by Lowell Fewster.)*

Ledgewood Farm is located on Route 171 (Old Mountain Road) in Moultonborough. The gambrel-roofed combination barn/stable with residence is part of the model farm compound of new buildings (including sheep barns and outbuildings) built for Thomas G. Plant's adjacent country estate, Lucknow, in 1913–1914 (now known as the Castle in the Clouds). During Plant's era, Percheron draft horses were housed in the stable. The estate property was broken up in 1942, and the farm retained forty acres. (Photograph by Cristina Ashjian.)

The Odell-Lester Barn is at 148 Portsmouth Avenue on the east side of the traffic circle, located in the heart of Stratham's Town Center district, across the street from the old town hall. The barn was built for James Odell, who also constructed the adjacent Greek Revival house in the 1850s. He later sold the property to Captain William Lester, and the Lester name appears on the 1892 town map at this location and has been used to identify the barn. (Photograph by Kate Crichton.)

The Jones Barn is at 18 Winnicutt Road in Stratham and is a classic mid-1800s traditional timber-frame barn. It has the off-set door on the front street end, with clapboard siding and board-and-batten on the other sides, which was common with New England barns. The basement walls are in excellent condition, made of mortared cut-granite blocks, rather than fieldstone. There is evidence of white wash in the basement, an indication that animals were housed there. The large barn doors have a track and wheels on the bottom as well, so they glide smoothly and don't blow in the wind. (Photograph by Kate Crichton.)

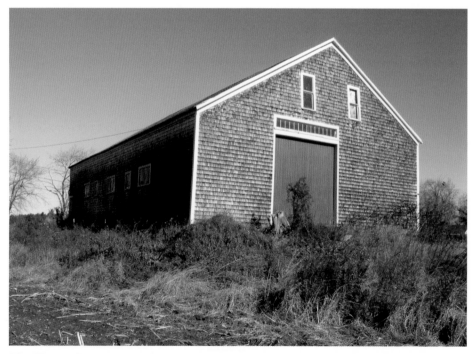

The Wiggin Barn is at 65 Squamscott Road in Stratham and is beautifully perched on a knoll in clear view of Squamscott Road motorists. It has recently had a new roof, trim boards, windows, and cedar shakes installed on the exterior walls. It has offset end doors and was constructed in the early 1800s.

The Jewell–Peabody Barn is located at 173 Winnicutt Road in Stratham. It is very intact and original and is connected to the house. The interior has some stick framing in between the large beams, making it a type of transitional barn framing characteristic of the late 1800s, when more milled lumber was used to build barns. Inside, there are some very ornate horse stalls with metal-lined mangers to prevent chewing. The original locking stanchions in the dairy stable also remain in place on the main level. It has a very majestic, large cupola, which has been beautifully maintained. (Photograph by Kate Crichton.)

The Wiggins-Raynes Barn is on 61 Newfields Road in Exeter. It is a highly visible barn, sitting in the apex of a sharp bend in NH Route 85. An old metal silo is attached to the far end, a vanishing symbol of a dairy farm, since many farming operations have shifted to horizontal silos. The barn is unique because it still has a vintage 1940s dairy stable in the lower level, with many of the locking stanchions in place. It also has a tiny milking parlor tucked in the back corner of the stable, which would have been an early forerunner of milking parlors used with the later free-stall barns. (Photograph by Joe Drapeau.)

The Scamman Barn is on 69 Portsmouth Avenue in Stratham and is a very visible icon from Route 108. It is still in active agricultural use for hay storage and livestock. It is an example of an off-set–style barn, with a larger than normal hay storage area on the north side. It is about a mid-1800s barn, which was used primarily for dairy. Then, in the early twentieth century, part of the interior was converted to poultry housing, which weakened some of the interior when multiple floors were added to accommodate hens. Other old buildings on the property are being preserved for use on the farm. (Photograph by Kate Crichton.)

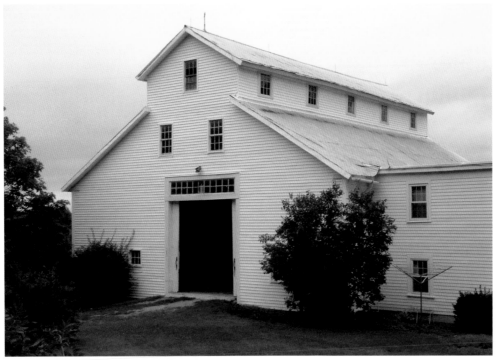

This monitor barn is in Dunbarton. It is one of the few of this style found in the state. The barn has the characteristic raised, covered window panels on the roof ridge, which could be used for ventilation, natural lighting, or viewing.

The Remick Country Doctor Museum & Farm in Tamworth was owned by the Remick family starting in the late 1700s. Dr. Edwin "Doc" Crafts Remick (1903–1993) served as doctor for Tamworth and the surrounding towns. Doc Remick left the homestead in trust, to be used as a museum; the museum opened in 1996. Shown across the farm pond are (left to right): the cattle barn, a New England-style barn which was popular in the region in the late 1800s; a milk house (c. 1934), which housed the pasteurization plant; a snow roller shed (c. 1875–1900) that once was most likely used as a tractor shed, it currently houses an antique snow roller; a maple sugar house (a recent addition to the property); and a horse stable (c. 1860). The museum is open year-round for visitors and offers seasonal events, workshops, classes and more. (Photograph courtesy of Remick Country Doctor Museum & Farm.)

Known as the Bachelder Farm after former governor Nahum Josiah Bachelder, this landmark property sits high on a hill off Maple Street in East Andover overlooking Highland Lake. Basic structural preservation work in the basement of the 1870s barn shored up the foundation and stabilized the support posts. N. J. Bachelder's Highland Farm was featured in the 1904 edition of New Hampshire Farms for Summer Homes *and other period publications. Bachelder served as New Hampshire's secretary of agriculture in the 1870s, and in the dual role of commissioner of immigration and agriculture in the 1890s. He was the mastermind of the New Hampshire Farms for Summer Homes initiative.*

Nichols–Tenny Farm is a well-known landmark along Pepperhill Road in Hollis. It was built around 1860 and was used for cattle, hay, and storage. The barn was extensively renovated from 1969 to 1971. Steel columns were used in the basement to support the upper floor and the granite foundation blocks were repointed. Its meticulously maintained exterior makes the barn a popular scene for calendars.

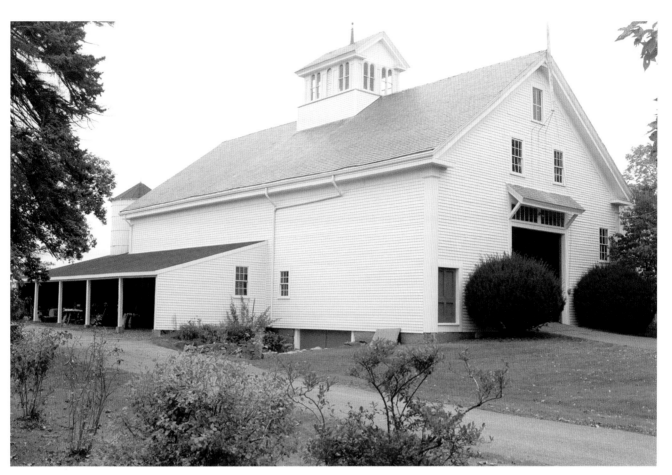

Previous owners of this barn in Stratham used pressure-treated lumber to replace the rotted floor boards and joists on the first floor. In the basement, the rock foundation was repaired, and new posts and beams were installed to stabilize the support of the structure. A poured concrete floor was added to the basement to discourage powder post beetles. Also, an extensive drainage system with pump was added to direct water away from the barn to a downward sloping field. Replacement of wood framework and windows in the cupola have now made this usable as a viewing area, and it is accessible by a series of winding stairways.

Blow-Me-Down Farm is just off Route 12-A in Plainfield. This barn was built in 1884 for a New York lawyer, Charles Beaman. The 60' x 100' three-story barn was repaired by the trustees of the Saint Gaudens Memorial. Extensive work was done in 1999–2000 to stabilize the structure and preserve it.

This large barn (45' x 145') is on Old County Farm Road, off Route 101 in Wilton. Originally this property was owned by Oliver Whiting in the early 1800s. It burned to the ground in the early 1830s. Oliver's son, David Whiting, cut the lumber and rebuilt the barn in about one month's time. Hillsborough County bought the property in 1867 and it became the County Poor Farm until 1897. It is now known in the area as the Old County Farm. Supports added underneath have kept the roof in good alignment, and they replaced the worn vertical boarding.

The Susan Colgate Cleveland Library/Learning Center at Colby-Sawyer College in New London utilized two pre-Civil War dairy barns. The barns were part of the old Joseph Colby farmstead adjacent to the campus. The restoration project was started in the winter of 1985 after new foundations were built underneath the jacked-up buildings. About one hundred extra beams were incorporated into the renovation to structurally outfit the building to accommodate the five levels of book stacks. The center was named for a descendant of Susan Colby, the first principal of the original Colby Academy.

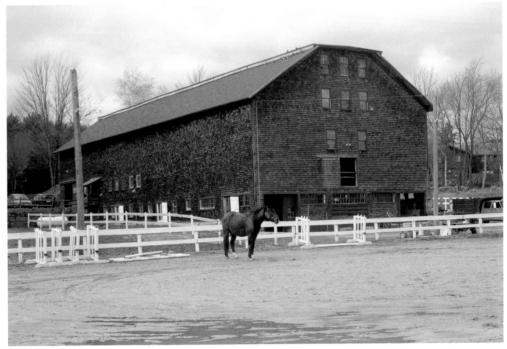

This barn presently serves as a horse barn in Temple. Over the years, it has been used as a horseback-riding school and summer camp. It was built around 1904 using convict labor from a nearby county facility. The owners have maintained a good roof on the barn to preserve it and done extensive preservation maintenance. This has a nearly flat top on the gambrel-type roof, which seems unique around the Hillsborough County area.

This Yankee-style, gable-front barn is along Route 4 in Boscawen. Extensive work was done in 1989, and parts of the barn were labeled and torn down so the foundation could be replaced. New vertical boarding was installed on the side-walls, which has aged beautifully over the years. The barn has been used for a commercial feed store and now is used to house family pets and storage.

The Lamson Farm was purchased by the town of Mont Vernon in the 1970s for the townspeople to enjoy and to preserve the homestead of one of the town's two original settlers. At the time of purchase, there had been nine generations of the Lamson Family in this country. Five of those generations lived on this farm. Basic repairs have been done to this old, modified, English-style barn. It measures eighty-four-feet long by thirty-two-feet wide and consists of two complete structures, which were probably moved here from different locations. The barns are attached in a manner that put two ends together, without filling in the section between them, which was an uncommon method. The barn is located on Lamson Road, off Route 13 in Mont Vernon.

The Yeaton Barn was built in 1951 and has been used over the years to house heifers and cows that were bought and sold as part of a cattle dealer business. A three-bag cement mixer was used to pour the entire foundation, which has been subject to frost heaving due to poor drainage. The owner has improved the drainage around the foundation and put new metal roofs on all the buildings to preserve them. The barn is located on Yeaton Road, off Route 25 in Plymouth.

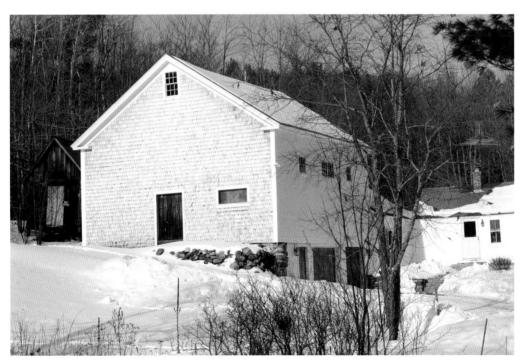

This old farmstead was known for many years as the Osborne place on Route 129 in Gilmanton. The barn was built in the late 1700s and housed dairy cattle and had an area for slaughtering beef. It still has an operating windlass, which is a pulley system for suspending the carcass during the butchering process. Extensive work was done to the barn, including jacking, straightening the roof, replacing part of the foundation and adding new siding, etc. It is now very functional as a garage and woodshed, with ample space for animal stalls.

Before – Demeritt-Bean Barn. This 32-foot-wide by 108-foot-long barn was built near Goose Corner in Farmington in 1780 by Paul Demeritt. Paul was born in Madbury in 1757, son of Major John Demeritt of Revolutionary War and Battle of Bunker Hill fame. The barn remained in the Demeritt family for five generations before being relocated. Three sets of double doors on the backside show the design to be three connected English-style barns. (Photograph by Dottie Bean.)

After – Barn contractors dismantled the Demeritt-Bean Barn, offering it for sale to be reconstructed elsewhere. This is the Demeritt-Bean Barn now reconstructed in Warner. It has been elevated four feet to provide nine-foot ceilings on the first floor, a full basement, plus the addition of a cupola, two-car garage, and more. (Photograph by Dottie Bean.)

Barn Re-use

As has been mentioned earlier, the challenge in maintaining old barns is that many are not being used for their original purpose: agricultural production. When barns housed cattle or sheep that were part of the owner's livelihood, attention was given to routine maintenance, because there was an economic return. A crumbling foundation, broken floor beam, or leaking roof was quickly addressed, since such problems had an impact on the daily use of the barn, the efficient chore routine of the farmer, and the comfort of the animals.

Today many former farms are part of a sub-divided development, and no longer retain a viable land base for agricultural production. Some historic barns are found on operating farms using large tractors and equipment, which don't fit between the many posts supporting these old structures. Often it is more efficient on a large farm to build a pole barn with trusses and no internal support posts, leaving the old barn to decay.

Barn preservationists are constantly looking for creative barn re-uses to make barns once again productive economic units, rather than buildings just used for dead storage or to accumulate junk and

By the 1950s, farmers were building single-story stanchion barns adjacent to the old barns to efficiently handle more cattle. The truss roof eliminated the need for support posts in the stable area. The Kimball Farm is a ninth-generation, bicentennial farm in Hopkinton. The single-story barn was built in 1962 to accommodate their milking herd needs and now has been converted to the Ice Cream Barn and Country Store and Museum. (Photograph by Lowell Fewster.)

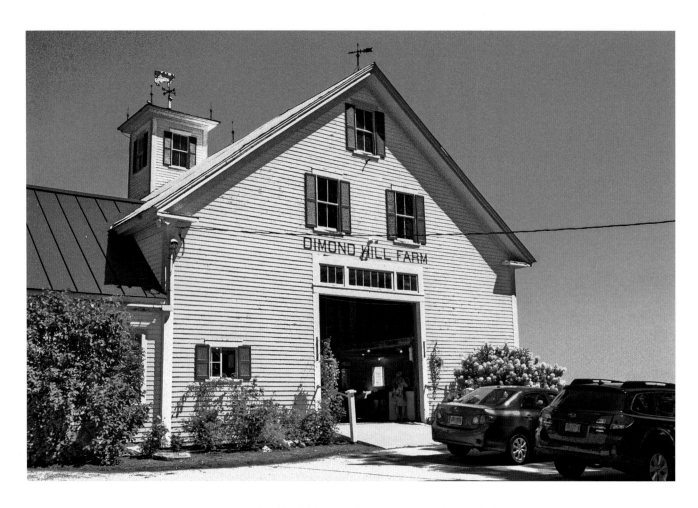

Dimond Hill Farm is on the Hopkinton Road outside of Concord. It is a classic example of barn re-use. This old dairy barn has been converted to produce preparation and storage and retail sales of fruits and vegetables. The farmstead is also used for special events. (Photograph by Lowell Fewster.)

gradually fall into disrepair. It is hoped that with any new or adapted use the structure will still look like a barn. Patio doors, bay windows, and dormer roofs can take away from the authentic, rustic, and scenic look of a barn.

For commercial farms that find old barns are no longer conducive to housing animals or containing the activities of crop production, the old barn could be used as a farm stand for selling value-added products. People love to go into an old barn and admire the beams and hoof-worn floors. Old agricultural implements can be used for decoration and create a very pleasant ambiance. Some farms use old barns for new ventures, including weddings and other community events, catering and restaurant functions. Solar panels can even be added to the roofs to provide an economic return in electricity savings for the farmstead.

Many non-agricultural businesses have moved into formerly agricultural neighborhoods and have creatively repurposed barns as restaurants, breweries, furniture stores, banks, yoga studios, and specialty shops, successfully using existing barn features to enhance their establishments. Although the first preference of preservation is always to maintain the structure on its original site and in its original context, many barns have been saved by being dismantled and moved to another site where they have a new viable, economic use.

Solar panels can be mounted on roofs of old barns to give an economic return by producing electricity. The roofs often slope to the south, giving maximum exposure. If the panels are mounted close to the roof's surface in a uniform pattern, they won't detract from the barn. This barn at Evergreen Farm in Kingston has twenty-six panels, which can produce about 100% of the farmstead's need for electricity. (Photograph by Nathan Merrill.)

This barn is one of the earliest examples of a Yankee barn in the Stratham area and was part of the Samuel Lane Homestead. It was built in the mid-1700s and added onto in the late 1700s. In 1973, the Collector's Eye was established in the barn. It began as a shop selling dried flower arrangements and antiques and is located in the middle of the Stratham traffic circle. The barn is protected with a preservation easement funded by the town of Stratham and the New Hampshire Land and Community Heritage Investment Program (LCHIP), and held by the New Hampshire Preservation Alliance. (Photograph by Nathan Merrill.)

INSET: *Furniture is displayed inside the Drake Barn at Hubbingtons Furniture in North Hampton, working around the existing posts and braces. (Photograph by Peter Rhoades.)*

Hubbingtons Furniture is in the old Drake Barn on Route 1 in North Hampton. Peter Rhoades had a vision for the run-down barn and renovated it into a retail store in 2015. The project received Federal Historic Preservation tax credits. They sell American-made furniture and have maintained the integrity of a classic barn. (Photograph by Peter Rhoades.)

Structural Preservation

Co-written by John Porter and Arron Sturgis, owner of Preservation Timber Framing, Inc.; with joinery drawings done by Jessica MilNeil, of Preservation Timber Framing, Inc.

Safety

Regardless of whether you are assessing a barn, working on a barn, or just taking a walking tour, safety must be of primary importance. These old barns have been standing for decades and things change. The floors may have weakened, braces and supports could have been removed, or openings have been left uncovered. Approach every barn as if there could be a potential weak spot just ahead. If in a group, keep space between people to distribute the weight. When walking on weak floors, stay near the edges. Don't trust an old ladder and have a person supporting the base. Old barns often have an accumulation of old rodent feces, which can be very toxic, so don't disturb these without respiratory protection.

Below are some general safety guides:

- Wear a hard hat at all times.
- Wear heavy work shoes with rugged soles to guard against injury and protect feet when stepping on nails.
- Work with a partner so that someone is available in case of emergency.
- Have access to a telephone or carry a cellular phone for emergency calls.
- Set up jacking areas so that lifting is done outside of the building or add framing to isolate and support damaged areas.
- Attach sheet material (plywood, etc.) between major supports of floors and roofs to provide firm working surfaces.
- Use safety harnesses and ropes when working on roofs, and stay off roofs on windy, snowy or rainy days.
- Set up staging with firm support at the ground level and put railings around work areas to prevent falls.
- Clean hay and debris from floors so that the condition of the area and the locations of holes and weak spots are evident.
- When walking in unevaluated areas, step from support to support, as shown by nailing patterns in floor boards.
- Carry out all activities slowly and with someone watching. Sometimes jacking or removing a brace will transfer stress to another area and cause a collapse.

- To reduce the hazard of stepping on nails, make it a policy to drive back nails or pull them out as you go. This will also make it easier to handle the lumber. Bending nails over only makes it harder to remove them later.
- Know your limitations and seek professional help with procedures that look dangerous or difficult.

Barn Assessment

Develop a Plan

Before starting a barn preservation project, pause for a while and develop a plan. This sounds basic, but barn contractors say that many people miss this important step, leading inevitably to later frustration on the part of both owner and contractor.

First, ask yourself your objective in getting into this project. Do you want to keep an old barn from falling down, to create a functional use for an abandoned building, or to restore the structure authentically? It is well to remember that *preservation* entails maintaining the structural integrity of a building as it exists today, while *restoration* implies the use of authentic materials and techniques to return the building to its condition at a point in the past, often the day it was built. There are big differences in the types of materials and the costs involved in the two approaches.

Second, ask yourself how the project will be done. Will it be a do-it-yourself project, will you use a local contractor, or will you employ a professional barn restorer? Barn repair projects can quickly get beyond the average person's abilities. It is important to gauge your personal limitations and to determine what skills need to be hired.

There are often many things that need to be done to preserve an old barn. You should develop a list of priorities at the start, so that the most crucial tasks are addressed first and limited funds are focused in the right direction.

The average person may need some help in assessing a barn's condition. This could be done

Visual observations can give a clue to potential structural problems present in an old barn. A sagging ridge line, bowed side walls, or a deteriorating roof indicate structural failures. These problems need to be addressed before the barn goes into further disrepair.

by getting assistance from a trusted friend with timber-frame building experience or hiring a contractor who specializes in old building repair. The New Hampshire Preservation Alliance offers assessment grants that share the cost of a visit from a skilled barn contractor. These can be as simple as obtaining notes the day of the visit or receiving a detailed report outlining the history of the barn and list of priorities for repairs. A thorough assessment takes time to look at all aspects of the building and crawling around in lofts and basements with a flashlight looking for structural deficiencies.

Exterior Grade

Beginning with the outside of your barn, inspect the surrounding grade. Years of use and animals and machines going in and out of the barn every day for over one hundred years can change the lay of the land surrounding a structure. Cow manure and mud combine each year to build up soil against exterior walls, essentially burying the sills and directing water to and under the barn.

The lilac and forsythia bushes, that decorative spruce tree now overgrown, all create areas of dampness around the barn and provide super highways for bugs and other critters to enter the structure.

Plan on cutting back overgrowth and re-grading the barn exterior to pitch water away from the building. These improvements are relatively easy to perform and provide the high economic return for your investment of time and money. You may be able to do a good deal of this work yourself.

Sometimes it is advisable to bring in an experienced site contractor and/or landscaper to correct the pitch of the grade around your barn. A drainage system at the base of your foundation can permanently move water away from the barn and save the structure. Improper drainage work, however, can accelerate the decay of your historic barn and wreak havoc on its foundation. Something as simple as a lined drainage trench with crushed stone under the drip edge can reduce splash-back and direct water away from the building.

Foundations

Inspect the foundation to see what it is made of and, if possible, determine if the foundation goes below the frost line or about four feet below grade. Many barns, especially early English barns, sit on minimal stone foundations. Often only point loads (where the posts sit atop the sills) are supported on rubble stone just at grade. Masons with great skills built many barn foundations with dry-laid stone. (Oftentimes, these early foundations are doing very well and can be saved with proper regrading and some stone restacking.)

As barns grew in dimension to accommodate advancing farming techniques and the increased populations of animals that were housed in barns, foundations became more substantial. Masons used stone extensively and built walls with great skill in order to support the structures above. Large pieces of quarried granite called "cap stones" were sometimes stacked above grade with rubble stone buried below. Bricks were also used, most often set in lime mortar above grade atop a rubble-stone base.

Water, time, and a build-up of soil around the barn are powerful agents of change. They often succeed in undermining what our ancestors built. Foundation failure can severely impact the framing of any barn, allowing the building to shift and drop and throwing the joinery out of square and level.

The repair of a barn foundation is determined by the extent of damage that has occurred over time and the quality of previous attempts to restore it. Concrete is often poured to bolster a stone foundation with limited success. Sometimes it is appropriate to remove the old stone and replace the barn foundation with modern concrete. In less severe cases and depending upon use of space, the existing foundation can be repaired to be serviceable for many years.

Barn Interior

As you enter the barn take note, as it is impressive and humbling. It can be overwhelming, and it might even be dangerous. Yet a barn remains intriguing and you will want to learn more about how it is built. There is a familiarity and a quiet sense of strength. It is a comfortable place full of the essence of time and good work.

If your barn was built before 1900, it is likely created from heavy timbers joined with mortise and tenon. These timber-framed buildings have survived as well as they have because of the methods used in building them. So, understanding how your barn was built is an important part of your thorough assessment. In the following pages, you can learn some basic elements of timber-framed buildings.

English barns were prevalent throughout New England, beginning with colonization and up through the early 1800s. These were smaller barns used primarily for subsistence farming, and they were characterized by a low pitch roof and doors under the eaves. As farming practices changed, these early frames were often significantly modified to keep up with the times. New larger barns were also built, referred to as Yankee barns, replacing the earlier family subsistence barns. Construction techniques also evolved, driven by the changing needs of farmers and by the availability of good timber: innovation motivated by necessity.

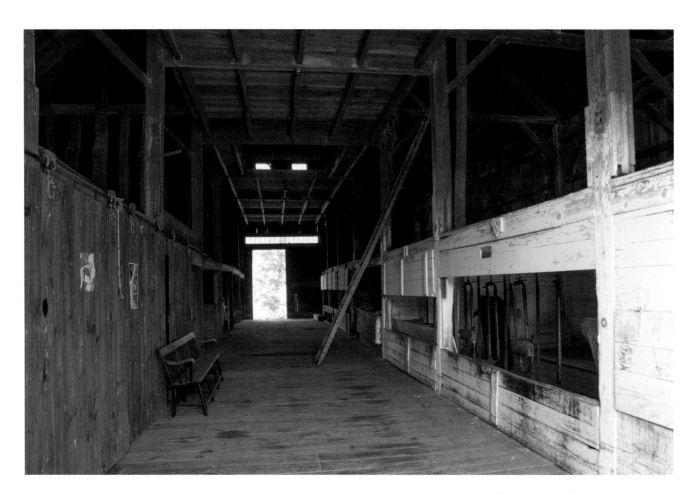

The interior of a barn can give many clues about its age and construction style. There may also be evidence of the accessories and equipment used when it was in operation. (Photograph by Lowell Fewster.)

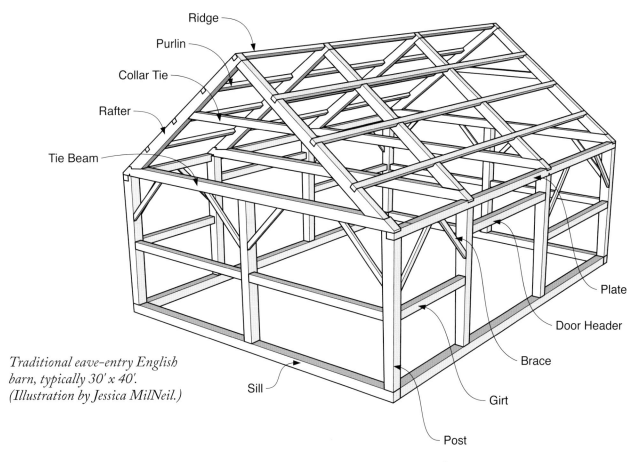

Ridge
Purlin
Collar Tie
Rafter
Tie Beam
Plate
Door Header
Brace
Sill
Girt
Post

Traditional eave-entry English barn, typically 30' x 40'. (Illustration by Jessica MilNeil.)

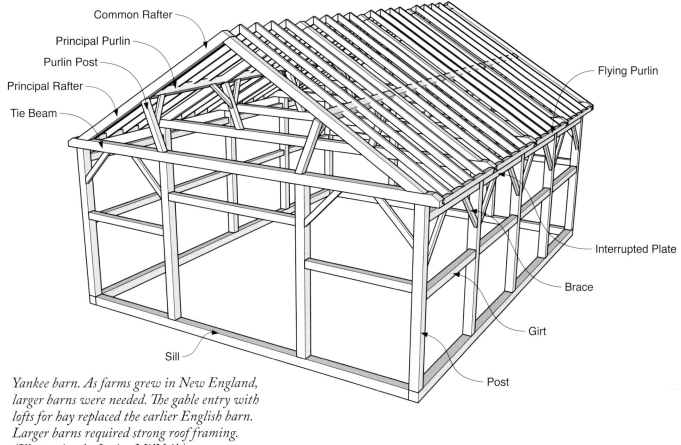

Common Rafter
Principal Purlin
Purlin Post
Principal Rafter
Tie Beam
Flying Purlin
Interrupted Plate
Brace
Girt
Sill
Post

Yankee barn. As farms grew in New England, larger barns were needed. The gable entry with lofts for hay replaced the earlier English barn. Larger barns required strong roof framing. (Illustration by Jessica MilNeil.)

Fixing Up an Old Barn

One approach is to do a small segment at a time. This provides an opportunity to evaluate your own work, or the work of a contractor, and to decide how to approach other segments.

Think about the pros and cons of renovating or salvaging your existing old barn. A new barn might seem a better solution to your current needs. Yet a modest-sized, "low cost" modern structure could turn out to be a poor choice when compared to spending the same money, or less, fixing up a somewhat rough old barn. This is especially true if you have some basic do-it-yourself skills, a love of history, and ambition. And don't hesitate to seek an occasional bit of professional advice and learn what others may have done.

Jon Vara is one person who had the courage to fix up his old barn. He later wrote about his successes in an article entitled *Giving Old Barns New Life* (Vara 1985). Since no two jobs are alike, cookbook-type instructions for barn repair can't exist. But all jobs require a methodical, common-sense approach with a concern for safety as the highest priority.

A good approach is to deal with the worst problems first. If the roof leaks, fix it immediately. Water infiltration is the major cause of barn deterioration. Observe poor drainage around the foundation, then do something to improve it. Clear away vegetation that may disturb the foundation or rot wooden sills or siding. Sills may rest on a collapsing stone foundation or a hodgepodge of support posts. Floor beams may be failing due to loss of internal support.

A barn will survive indefinitely with a sound roof and a reasonably decent foundation. Once roof and underpinning are secured, you may make other repairs as time and finances allow. Low-cost metal roofing could be screwed in place to cover bad areas and then removed during renovation. An effective way to upgrade a mortised-and-tenoned barn frame may be to work on one bay at a time. If a lot of jacking will be required, the best results are often obtained by bringing the entire frame into plumb and level condition before repairing the smaller segments, as a rigid roof grid will interfere with jacking.

Time-and-materials contracts are common in barn renovation projects. A complete one-price bid is difficult in a barn project because there are so many unknowns. Even with a time-and-materials contract, it may be hard to estimate the ultimate cost, because unforeseen repairs may be encountered along the way. But a good contractor should be able, at least, to figure the price range you should expect for the project.

It is often advisable to tackle barn projects in stages and have your contractor itemize the approximate cost of materials and labor for each segment. Then, if there is an overrun in cost, the project can be stopped with one phase completed rather than leaving an entire project half-done and perhaps in a condition of structural jeopardy. Many barn renovation projects are undertaken over a period of several years.

The real workhorse joint in most barns is the mortise and tenon. This could be used for a horizontal member attached to a vertical post or on attached support posts to the sill.

The end of a floor joist that rests against a rotted sill may also be rotted. Check to see how far the damage has advanced to be sure it has not affected the structural integrity of a floor.

Barn Stabilization

Before repairing your barn, it is important to make it stable. Once you understand how the barn was constructed, you can determine the best way to stabilize it and make it safe to work in.

Cribbing

Cribbing is perhaps the most effective way to stabilize your barn and is straight forward and uncomplicated. It is safe and reliable. Cribbing is the process by which short timbers usually measuring 6" x 7" and 4' in length are uniformly stacked to support a failing timber beam. The reason for two dimensions instead of something like a 6" x 6" piece is the flexibility in determining the height of the cribbing and the ability to insert cribbing at any one layer for the placement of a jack or other lifting device. By using the short or long dimension of the cribbing piece, you can alter the height of the cribbing pile as you get closer to the element you wish to support. The key to cribbing is two-fold:

(1.) Cribbing must begin level and be laid uniformly. No cribbing pile is safe if it is not level. If you are working from the ground, it is essential to excavate an area large enough to set the base of the cribbing pile level. This is not difficult to do. It requires a short level and a shovel. Sometimes where the land is rocky or very uneven, it is possible to bring in gravel and sand to create a level surface for the cribbing pile.

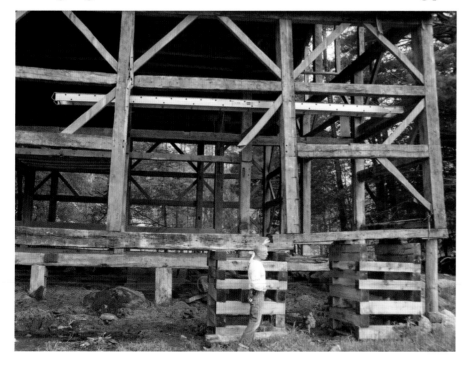

Cribbing with short timbers can be a safer way of supporting a barn during the repair process. (Photograph by Beverly Thomas.)

This is effective if the gravel is compacted and the surface is level. As the cribbing pile is built, set two pieces parallel, four feet apart from each other. The second layer of cribbing is laid perpendicular to the base and the third layer is set parallel to the base. It should be checked for level regularly. Alternating perpendicular and parallel layers provides incredible stability to the cribbing pile and it can accept tremendous weight. Cribbing should be of uniform size and it should be of good quality timber. Any species can be used as long as it is good quality. Softwoods will not carry the same weight as hardwood species, but in barns there is almost never that much weight in any one location.

(2.) Cribbing should be uniformly stacked. The pile should remain plumb and of equal size. In other words, stack four-foot cribbing in a four-foot square. Sometimes space requirements mandate smaller cribbing piles. This should be avoided unless there is no alternative. The smaller the base of cribbing, the less stable the pile. Cribbing can take the place of a crumbling foundation. It can create a temporary post to support a tie beam. It is also the base from which one can jack up and straighten the building. Cribbing can move. If cribbing is placed to stabilize a building, it should be checked regularly to ensure that the element it is supporting is still bearing upon it. This is critical after the first twenty-four hours and/or after any significant rain or snowfall. Cribbing will settle once it begins to carry the weight of the building. Rainwater can undermine cribbing and snow may indicate a hard frost, which can heave up the earth, thus affecting the cribbing pile.

Cross Bracing

Sometimes a frame requires cross bracing to ensure that it does not continue to spread apart during the stabilization of the barn. Cross bracing is the method of nailing or screwing a new piece of dimensional lumber to an existing structural member and connecting it with an adjacent member. This effectively restrains the damaged element and stiffens the frame until repairs can be made.

Kiln-dried dimensional lumber is best for cross bracing. It is light, durable, and unsightly. It is important to make sure that stabilization of your barn is done in an unattractive manner so that you are not lulled into thinking that your barn is fixed. Sometimes you can even use plywood to gusset and cross-brace damaged elements. It is for this use only that plywood should be used in any old barn. Plywood is expensive and rarely lays out properly on traditionally built buildings. Stabilization of the structure is a critical first step in repairing your barn. This also gives you time to plan your preservation effort and raise the money you will need. Safety is paramount.

One other area of stabilization that is crucial to the longevity of your barn is the weatherization of your roof. A proper roof will sustain the most damaged barn. If your roof leaks, your barn immediately suffers. In most cases, a leaky roof can destroy a barn in less than five years. Stabilizing the roof can be treacherous. While cribbing can be done by almost anyone, usually roof stabilization should be done by professionals. If the roof deck is damaged, then being on the roof is most certainly dangerous. You must assess the roof from the inside. Supporting the roof using cribbing from the ground may be called for if the roof is heavily damaged. Oftentimes, cross-bracing can be employed from the tie-beam level to stiffen the roof system. Open and damaged roof decks can be bolstered from below, or boards can be laid over the damaged areas and secured to provide temporary weatherization.

Repairing the Barn

Two forces are constantly affecting your barn: compression and tension. The barn's ability to resist compression and tension determines its lifespan. Compression is produced by the weight of the barn itself (dead load) and the weight of water and snow (live load) on the structure. Compression failures occur when the frame can no longer hold up the dead load and the live load. This results in the crushing of the frame. Wood is extremely good at resisting compression unless it becomes wet and rots.

Tension is the frame spreading apart. Wind loading and snow loads can also create tension in the frame. The result of this tension is the spreading of joinery in the frame. Wood is less able to resist tension than compression. Timber frame joinery must then be designed to optimize the strength of the wood to resist these forces.

Several system failures contribute to the reduced ability of the frame to resist compression and tension. These failures result in the misalignment of your barn. Foundation problems can allow the frame to rack, twist and drop. Water penetration at the roof and/or at grade can rot the timber elements of the frame, leaving portions of the building unsupported. The building can spread open with excessive roof loads as well.

Repairing these problems requires a systematic approach. This approach can be successful only if you and your preservation contractor have a full understanding of your building, how it was built, and what issues must be addressed. With a thorough barn assessment under your belt, you have measured your barn, stabilized your barn, and determined a plan of action for repairs.

If you have determined that you have enough resources to complete all the structural repairs in your barn, then it is wise to begin from the bottom of the barn and work up. If, however, you need to meet certain budget requirements and phase the work over several seasons, it is extremely important to address any roof leaks or grade issues that cause water to continue flowing into the barn. As noted earlier, grade work is usually inexpensive, and the payoff is significant. Roof work is trickier, but stabilization efforts should provide a roof that keeps the barn dry.

Very rarely can one say a barn is "too far gone to be saved." This may be spoken by someone who does not understand the importance of your barn and who perhaps simply does not have the skills necessary to complete the work. In that case, it might be wise to seek another opinion.

Jacking or Lifting Your Barn

Important Building Jacking Cautions

Before proceeding to further sections of this book, which deal with the repair of foundations and walls, please read this section carefully. There are many dangers associated with jacking buildings and repairing members. Most repairs should be left to experienced barn contractors. The authors have made no attempt to thoroughly describe every detail of a safe and successful repair. Experience, good judgment, and common sense are absolutely essential.

This book includes several photographs and illustrations showing structural members being lifted by hydraulic or screw-type jacks with posts on top. Jacking is a deliberate task and can be dangerous if not done properly and should often be left to the professionals. A jack with a post has a tendency to twist when the jack is screwed upward, and for the jack to tip and the post to kick out.

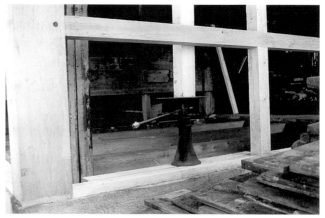

Screw jacks are preferable for jacking up old barns. These have a slow action and can be raised in small increments. Jacks must be set on a firm base and a solid jacking post needs to be kept plumb on top of the jacks to lift the building. A half-inch-thick steel plate on top of the jack will help prevent a penetration of the jack into the post and give a firmer lift.

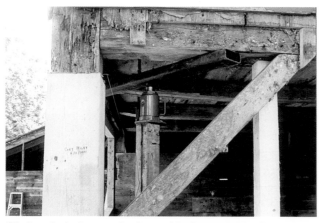

Hydraulic jacks can also be used in barn repair. Care must be taken to raise them up in small increments. These jacks are less subject to twisting while lifting. Renovators usually prefer twelve- or twenty-ton jacks, depending upon the size of the job. This shows a rugged metal post used as a base support.

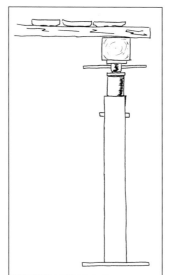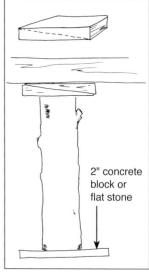

2" concrete block or flat stone

To minimize the number of jacks needed on a project, the jacked areas can be supported by jack posts to temporarily hold support headers in place (left illustration). They can be jacked snugly into place and then the jacks removed for use elsewhere. Jack posts need to be used with extreme caution. They are not made for heavy loads. Less expensive bearing posts can be improvised using a piece of timber or a round log (right illustration). It should be cut close to the length needed and then two angled wedges driven in to snug it up. Peel off the bark before use and consider this a temporary support.

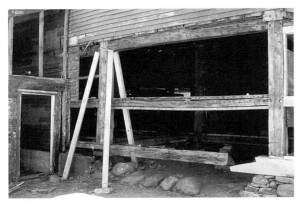

The Process of Jacking

Your barn in every way wants to be back in its original position; however, it took a long time for it to sag into its present position, and it is a slow process to ease it back to the original state and have it settle into place.

There are two types of jacks used to lift objects. Screw jacks are cast metal with a large, threaded rod and swivel head that can be placed on level cribbing and turned with a bar to lift the building. Screw jacks are operated manually, and the craftsperson maintains great control over the amount of force used to lift the building. Once repaired, the barn can be let off the jacks in a very controlled and peaceful manner. In many cases the strain on a screw jack can indicate to the craftsperson where the building is most comfortable.

Hydraulic jacks are also made of metal with a telescoping shaft that lifts when hydraulic oil is pumped into its cylinder Unlike the screw jack, the hydraulic jack does not indicate changing levels of strain on the building to the craftsperson. The hydraulic jack can be pumped to the breaking point of what it is lifting before you know it. They also release their lifting strength very quickly when the release valve is turned. Additionally, they tend to lose a portion of their lifting strength if left for any length of time.

Both jacks are useful tools when lifting a barn. The placement of a jack and the quantity needed to adequately support a wall span is best left up to professional craftspeople. It is distinctly possible to severely damage both yourself and your building with the ill placement of a jack. It is also very possible to lose the building you are jacking if you leave the jacks unattended. Cribbing, as described earlier, should be added to support the building as the jack is lifting. In this way, the barn is always on solid footing.

The screw jack with a threaded rod and swivel head allows for slow raising and lowering and is a safer choice for lifting a barn.

Barn repairs often involve the removal of major support systems to replace rotted sills, etc. A secure, temporary support must be put into place to stabilize the structure while it is being repaired. A tripod such as this can hold things securely.

House jacks, the tubular telescoping jack with a small threaded rod at its head, should be avoided. They can be a moderately effective stabilization tool, but they cannot safely support and lift a structure.

When using a jack and a lift post on a small job, follow these basic steps:

• Try to keep the post as short as possible.

• Mount a half-inch-thick steel plate between the jack and the post so that there is better lift and the head of the jack doesn't penetrate the end of the post.

• Place the jack on a firm surface, such as several 6" x 7" crib pieces pushed together with a 2"-thick by 10"-wide wooden block to spread the load on the cribbing.

• Put temporary supports in place to stabilize the structure as necessary during the jacking process.

Foundations

Foundations are another major source of failure in old barns, and these repairs often require the jacking techniques mentioned earlier. When the foundation gives way, it affects the entire structure. Sills may crack, the roof may sag, leaks may develop as the building frame starts to move.

Many foundation failures are caused by poor drainage around the building. Poor drainage can be caused by:

- A buildup of water around stone foundation walls, followed by freezing and thawing that dislocates stones and footings;

- Running water, causing erosion that can undermine foundation bases; or

- Splashing water from the eaves, which may rot lower wall boarding and eventually the sills.

Foundation failure will weaken the barn and cause tension on the joints. This can be repaired by replacing the rock wall or with a new concrete foundation.

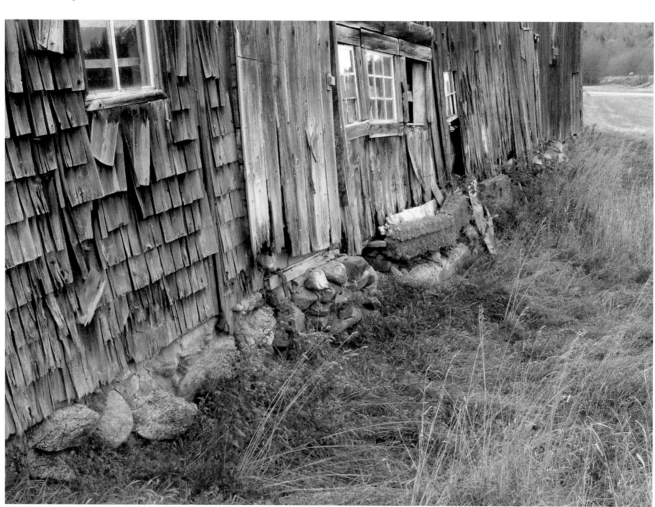

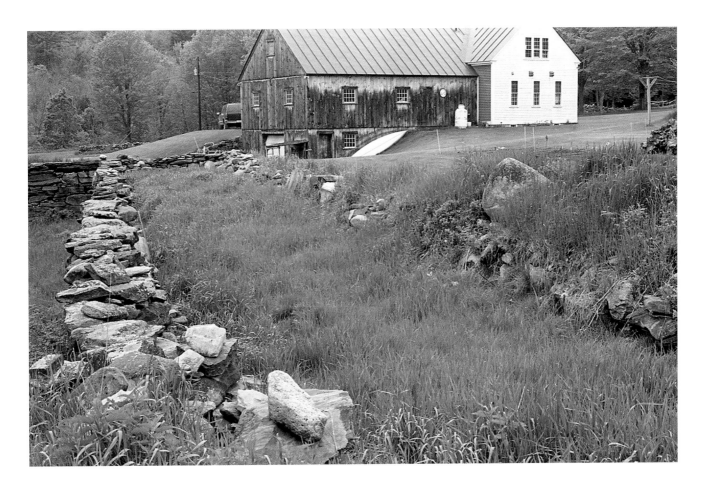

Improving drainage may be as simple as grading around a site to create a slope that will guide water away from the building. Water bars, ditches, and culverts can be used around a site to keep surface water from reaching the structure. A bed of small, crushed stone under the dripline of a building can prevent the growth of weeds and minimize the splashing of rainwater onto the lower boards and sills.

Ground-level foundations on side-hill barns seldom went below the frost line. Such shallow footings depended upon the insulation afforded by manure stored in the cellar to prevent frost damage. When these barns are empty and exposed, their foundations are often lifted by frost, and fail. Digging below the existing foundation and pouring footings and support walls may be necessary to repair frost damage. If the load-carrying capacity of the original foundation is questionable, a parallel system of beams and posts can provide additional support.

Barn foundations often show evidence of water erosion and frost damage. This rock foundation apparently had a major supporting foundation on the uphill side under the west portion of the former barn. This protected the full basement supporting wall under the center drive-through aisle from water drainage on the side-hill site. The ridge pole ran parallel to the slope, putting eaves run-off uphill of the stone foundation.

When preserving old barns, if the stability of the outside foundation wall is questionable, an interior row of posts with support beams can add extra strength.

Sometimes major support beams in old barns need a parallel system installed to take the load off brick or metal columns that may have deteriorated over the years. It is very common to build an all-new-timber first floor, as these times require a stronger floor for heavier loads.

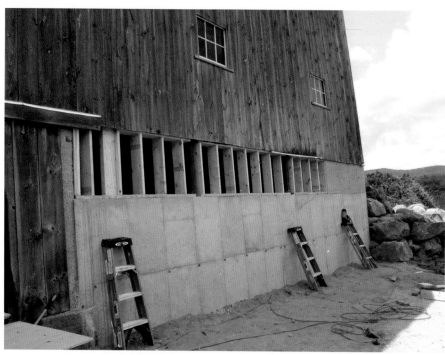

A new concrete wall below the frost level can save the barn. The wood wall allows a transition between the concrete and the original sill. This wall can blend into the original stone walls, if they are sound, or be covered with exterior boarding.

Repairing a foundation often involves jacking the building, rebuilding its underpinning, and re-grading the surface so that water drains away from the structure. Some contractors have developed innovative methods of pushing a bowed stone wall into alignment, but the best repair is usually the rebuilding of the wall using its original stones. Consider a new, reinforced concrete wall only if the existing foundation isn't historically important.

Repairing a Foundation

It is important to support the superstructure properly while doing foundation repairs. Old-fashioned screw jacks or barn jacks are desirable tools to use in lifting a barn because they can jack slowly in small increments. More modern hydraulic jacks can also be employed if they are used cautiously to lift in small increments. Always back up a jack with cribbing or post in case of failure, especially if the jack is left in place overnight or for an extended period. Keep a sharp lookout for any sign of movement of the jacks other than a slight settling down as they begin to take the load. Such movement often indicates a danger of the jacks kicking out to the side, with potentially grim consequences. Lift only two to three inches a day to minimize stresses on the structure (Vara 1985, 52–54).

Just as important, listen carefully. Turn off the radio, keep conversation to a minimum, and tune in to the creaks and groans of the shifting barn. You're moving a tremendously heavy object that probably hasn't budged—except for an imperceptibly slow settling into its present position—in at least a century. Expect a few squawks of protest. Such sounds may make you nervous, and they should. Don't expect to raise the building into position in a day; sometimes it takes weeks of jacking to put a barn into proper position (Vara 1985, 53).

Systems of support need to be designed that will lift the weight of the building off the foundation and allow working space to dig, build forms, etc. Setting the jacks on a firm base four to six feet out from the foundation, and eight to ten feet apart, can make it possible to set piles of cribbing to jack a cross-beam (often called a "needle") that will lift the building. Be sure that loosened frame parts (especially braces) are fitting back together as the frame is being jacked. Always jack at major supporting posts.

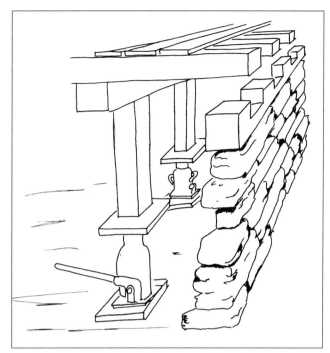

When removing an old sill, use a heavy beam temporarily fastened with duplex nails to hold it in place under the floor joists while raising with jacks. This stabilizes the area for removal of the deteriorated sill. Whether on a concrete, dirt, or wood floor, a large enough support should be put under each jack to distribute the load. If the ground is soft, a support crib should be constructed of several stacked timbers.

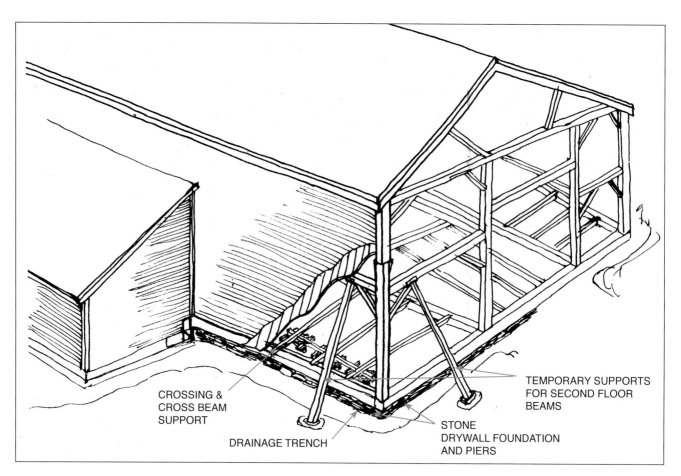

CROSSING &
CROSS BEAM
SUPPORT

TEMPORARY SUPPORTS
FOR SECOND FLOOR
BEAMS

DRAINAGE TRENCH

STONE
DRYWALL FOUNDATION
AND PIERS

It is wise to repair a barn in sections and properly support the area to allow for repairing the foundation and replacing deteriorated beams. (Sketch of the renovation of the Chet Riley barn in Hampton by Shane Baker.)

Joinery and Structural Members

Roof and foundation failure will often result in secondary impacts on other structural members. If the side walls have pushed out, it may be necessary to remove the exterior siding to gain access to frame members for jacking and repair.

You may need to build a crib in the cellar to provide support at ground level for jacking. A jacking beam or needle is then extended to jacks located outdoors so that lifting can be done outside the building. Pieces of 2" x 4" stock, or steel angles, can be attached to vertical posts to provide a ledge for jacking.

The removal of rotted posts or purlins may require the disassembly of a notched joint. Mortise-and-tenon joints, anchored with wooden pegs or long nails, were often used to fasten members. Take care when removing pegs and long nails, as jerking of the ladder could cause part of the structure to collapse or a worker to fall. Framing members may have rot damage due to the decay of exterior boarding. These support posts and girts need to be repaired before replacing the siding.

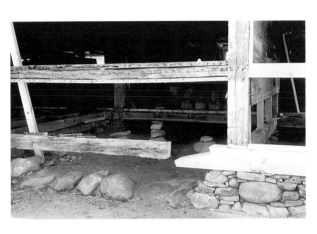

Scarfed joints are often connected with a tapered notch 18"–24" long that interlock the connection and make it possible to put pegs through the joint to hold it securely.

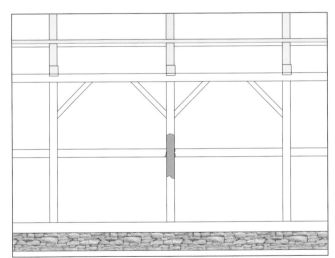

To replace a rotted area at the intersection of a post and beam, position temporary posts in the top and bottom section and put the lifting jacks in the middle. The temporary posts are important to transfer the weight load to the foundation. Once supported, the rotted part can be cut out and a suitable connecting joint made to accept the new pieces. It would be preferable to extend the new replacement pieces to the next major joint and avoid the splice. (Illustration by Jessica MilNeil.)

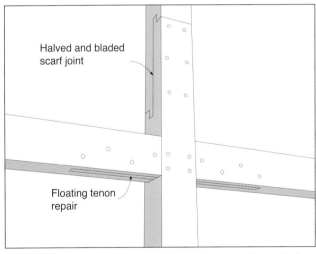

Halved and bladed scarf joint

Floating tenon repair

One way to secure a post and beam joint is with notched connections anchored into place. To be effective, the laps need to be twice as long as the thickness of the beam. A 6" x 6" post needs a 12" lap. (Illustration by Jessica MilNeil.)

Traditional Joinery Repair

Repairing your barn using traditional methods is the most economical way to ensure that your barn will last for generations. It can be argued that spending the extra time finding the proper materials and using traditional repair joinery techniques to repair your barn is cost prohibitive. It is true that your initial investment will be larger than if you had only done part of the job by simply adding lumber or steel gussets to the frame and slapping a new roof on. Remember, however, that you have spent a great deal of time getting the barn to this point through the lifting process. You

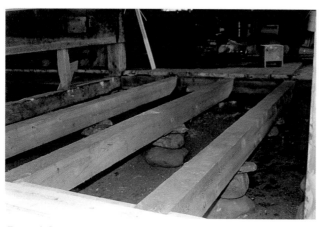

Rotted floor supports often have to be removed and new beams put into place. These were rested on short stone pillars and then fitted into the joint on the ends.

have eliminated the grade issues facing the barn that caused the damage and you have acquired an appreciation for your barn unmatched by your thorough assessment of it. The extra few hours spent on creating repair joinery with like materials will pay handsomely down the road when the barn remains standing for your grandchildren. It also increases the value of your barn for sale, and it allows you to meet grant standards and requirements. The biggest reason for repairing your barn traditionally, however, is that it looks really good, it is super strong, and it will make you happy.

All the joinery you will need to use in repairing your barn has presented itself to you during your barn assessment. Whether your barn is new or old, the repairs you make to it should reflect the joinery techniques of the original builder. This is in keeping with the historical value of the barn, but also the structural integrity of the building as well.

Unless the original joiner made serious miscalculations in his barn design or chose inferior materials for the job (which is not the case if your barn is still standing) you can rest assured that his methods were sound and worth repeating.

Repair joinery can take many forms. Perhaps the most useful, beautiful, long lasting, strong, and versatile forms of traditional repair joinery are the scarf joints.

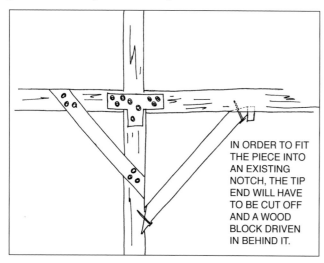

IN ORDER TO FIT THE PIECE INTO AN EXISTING NOTCH, THE TIP END WILL HAVE TO BE CUT OFF AND A WOOD BLOCK DRIVEN IN BEHIND IT.

When diagonal knee braces have rotted, these can be replaced without jacking, because they are not usually load-bearing members. A 2" x 8" can be bolted to both sides of the beam, as shown on the left, or a new piece of timber could be notched into place, as illustrated on the right side.

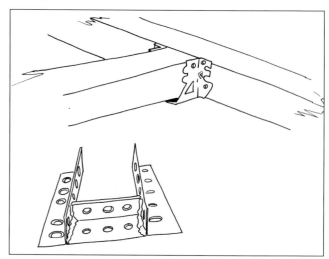

A good way to tie a repaired joist to a new sill is to use either a prefabricated joist hanger or make one by welding three pieces of galvanized angle iron together. Special hanger nails must be used to hold it in place.

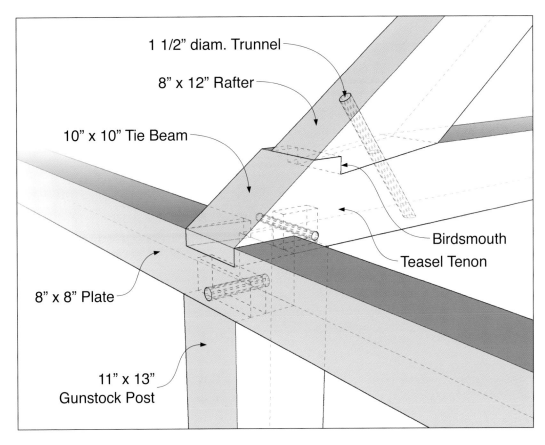

1 1/2" diam. Trunnel

8" x 12" Rafter

10" x 10" Tie Beam

8" x 8" Plate

11" x 13"
Gunstock Post

Birdsmouth

Teasel Tenon

Early English tying joinery. The large trunnel connecting the rafter to the beam is prevalent in New Hampshire. The trunnel replaced the earlier mortise and tenon joinery. (Illustration by Jessica MilNeil.)

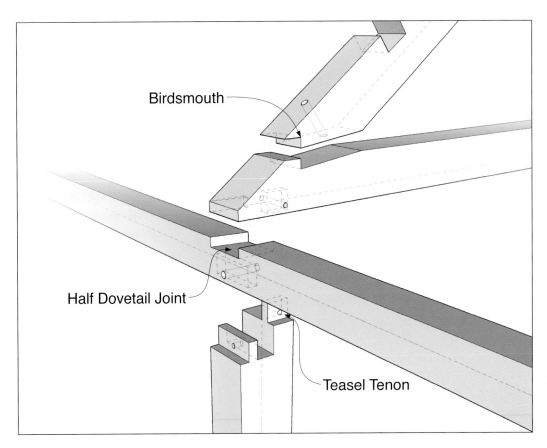

Birdsmouth

Half Dovetail Joint

Teasel Tenon

Early English joinery (exploded view). (Illustration by Jessica MilNeil.)

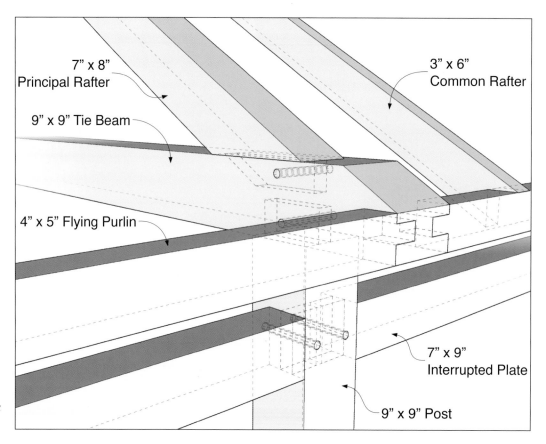

7" x 8"
Principal Rafter

3" x 6"
Common Rafter

9" x 9" Tie Beam

4" x 5" Flying Purlin

7" x 9"
Interrupted Plate

9" x 9" Post

Yankee barn (typically 40' x 60'), view at the top of the wall showing the top plate with the flying purlins and rafters, which created the eave overhang. (Illustration by Jessica MilNeil.)

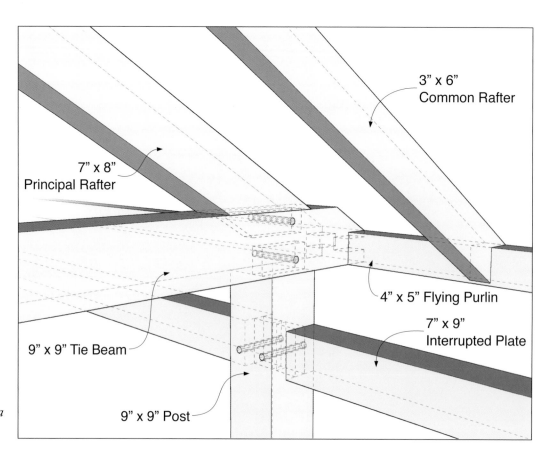

3" x 6"
Common Rafter

7" x 8"
Principal Rafter

4" x 5" Flying Purlin

7" x 9"
Interrupted Plate

9" x 9" Tie Beam

9" x 9" Post

Yankee barn with another view of the top plate with the flying purlins and rafters that more clearly shows the overhanging eaves. (Illustration by Jessica MilNeil.)

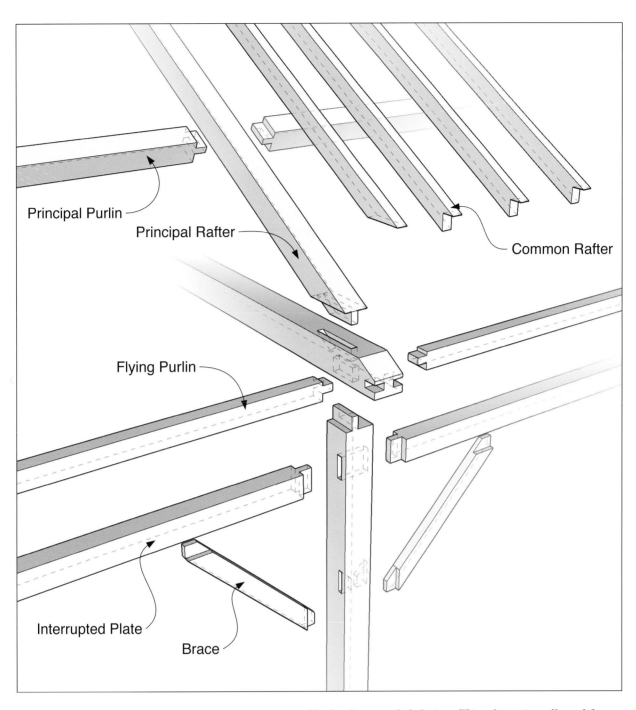

Principal Purlin

Principal Rafter

Common Rafter

Flying Purlin

Interrupted Plate

Brace

Yankee barn exploded view. This adaptation allowed for an eave overhang, important in New Hampshire winters. The joinery is simplified for the ease of construction and meeting the needs of the farm expansion of that time. (Illustration by Jessica MilNeil.)

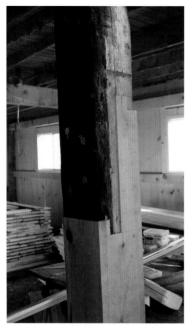

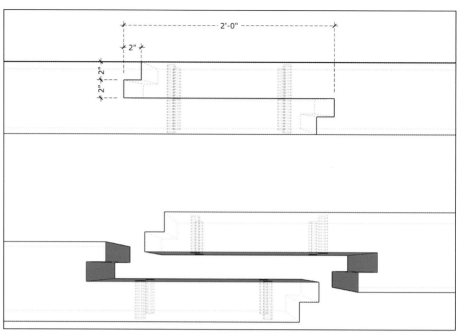

The bladed scarf joint can be used successfully both vertically and horizontally. It is easy to construct and much stronger than a simple half lap joint. (Photograph by Jessica MilNeil.)

Common repair joinery: the bladed scarf joint. (Illustration by Jessica MilNeil.)

Scarf Joints and Free Tenons

The scarf joint is defined as a joint between two timbers meeting end to end. A favorite scarf joint is the "bladed scarf" (see sketch). The simple addition of the blade in this scarf measurably increases the structural strength of what would otherwise be a simple half lapped joint. It is easy and fast to execute and is versatile. The bladed scarf can be used in both vertical and horizontal applications.

Chances are good that somewhere in your barn you will discover a scarf joint bringing two beams together. If you find such a joint, copy it in your repairs. You will not only be repairing your barn for the long run, you will be preserving the joinery techniques of the original builder, perhaps even of your grandfather, his neighbor, or a friend.

Free tenons or floating tenons are another method of joinery used extensively in repairs. By definition, the free tenon is a loose tenon mortised into two timbers touching each other. The free tenon is not part of each of the joining timbers but it is generally pegged to both. A free tenon can be used effectively where a girt engages a post. Another common use for the free tenon is at the bottom of a post where it engages a sill. Usually the free tenon is necessitated by damage or rot in the original tenon of one timber engaging another.

Often, a post may have lost its original tenon where it met a rotten sill. The bottom shoulder of the post may be fine, but the connection to the sill is lost. The free tenon allows the two elements to be reconnected without significant loss of the original fabric of the timber. Cutting repair joinery takes some time and practice but is well worth the effort. Your attempt to employ traditional techniques, even if a little bit rough around the edges, far exceeds the strength acquired by pressure treated lumber and gun nails.

Pressure-Treated Lumber

Modern building methods and materials are readily available and can be used to repair your barn. Pressure-treated lumber is supposed to last about thirty years. Your barn may be two hundred years old. Pressure-treated lumber is often plantation grown, meaning it is grown very fast and harvested when it meets minimal size requirements for the element to be created. The quality of the wood is thus suspect, as are the chemicals used to treat the wood, with regard to the environment. These materials are usually more expensive than seeking like material from your local custom sawmill. A little research will yield these custom mills and you can still find high quality, reasonably priced timber for your repairs. You simply need to know where to look. Many logging practices and economic pressures from the contemporary building industry largely disallow forest management based on a long-term, slow-growth, sustainable-harvest perspective. Trees growing straight and tall are cut too soon and are, therefore, harder to find.

Steel

Whether in the form of bolts, lag bolts, cables or plates, steel can also be effectively utilized in the repair of your barn. In many cases, you already have steel elements used in the construction of your barn. As in any repair decisions, you will need to balance the strength, beauty, and longevity of the repair with costs and aesthetics.

Steel is strong and can resist tension better than any wood species. It can, therefore, be used in smaller size to gain great results. A well-placed metal strap over the end of a tie beam or at the base of a king post truss not only looks appropriate, but it also dramatically increases the strength of the joint. Metal "dogs" which are basically large staples, have been used successfully in original and repair joinery. The use of steel is ineffective if it is used against rotten wood. The tendency to apply a quick fix with steel straps or lag screws is misguided if the wood to which the steel is applied is decaying or rotten.

When repairing an old barn, large beams are often needed to replace rotted sills. These are available rough-sawn from many local mills.

Large, steel plate stock is almost never warranted, whereas it provides more strength than is required for the task it is to perform. Plate stock also has the tendency to condense moisture between it and the wood it is attempting to bolster. This can accelerate the decay of the original wood fabric.

There are concerns about expansion and contraction rates of steel plates vs. wood. Damage to wood elements, expanding and contracting at different rates than the adjacent steel element, can occur.

Concrete

Concrete has been around in some form or another for hundreds of years. Modern concrete became available around the turn of the twentieth century. Poured concrete blocks were first introduced in the first quarter of the twentieth century and increased in popularity after World War I. In recent times, concrete has become the material of choice for foundations and floors in barns. It is versatile, easy to work, and provides a safe, sanitary floor on which to work. As farming changed over time and dairy herds grew, concrete was considered a god-send. It provided a solid, easily cleaned and maintained floor and stanchion area for feeding and caring for cows.

In many old and new barns, concrete has been used extensively to repair and bolster the original construction. In older wood-framed structures,

you often see concrete poured where original wood sills have rotted away. In many instances, the concrete was used to keep the barn standing and the farm running. In this context, farmers, forced by high operations costs and low profit margins, have successfully repaired their barns with concrete. The long-term association of concrete and wood, however, has its consequences.

As with steel, if concrete is used to bolster wood that is decaying or rotten, it can accelerate the deterioration of the barn. Concrete also has considerable weight to it, and this can stress a wood structure considerably. As a foundation material, it can be well utilized. In many cases, concrete has been used to bolster existing stone foundations. In other instances, it has entirely replaced the original foundation.

New concrete foundations are usually placed on concrete footers below the frost line, which is generally accepted at four feet below grade. Your old barn can greatly benefit from a new concrete foundation if it has been repaired properly.

The existing stone beneath your barn may prove as adequate for the task. An experienced mason can help you regain the structural strength of your foundation. It is optimal to have the frame of the barn level and repaired properly prior to the foundation being repaired. While this may seem counter intuitive, remember that during your assessment and stabilization of the barn you recognized that the frame was misaligned.

With the frame leveled and repaired, the foundation can be brought to it and the barn supported properly. Foundations that are placed in the wrong place or are too large or too small for the frame will accelerate decay.

Exterior Sheathing

On early barns, wood sheathing was often applied vertically over horizontal girts with interior or exterior battens. On later barns, there were studs and horizontal sheathing, typically covered with clapboards or wood shingles. At the base of exterior walls, roof water can splash onto the barn, deteriorating the sheathing and sills.

When only small areas of exterior side walls are in poor repair, sections may be repaired as follows (Wooley 1943, 7–8):

- Square a line across damaged boards at a point above the damaged section. Saw across the boards to eliminate damaged parts. Sawing on a bevel will help to shed water.

- Secure a piece of metal "Z" strip long enough to go across the opening to weatherproof the joint. You don't need a "Z" strip if you cut up to the wall purlin.

- Nail a 2" x 4" or a 2" x 6" near the top of the opening as shown.

- Saw boards to length and nail in place.

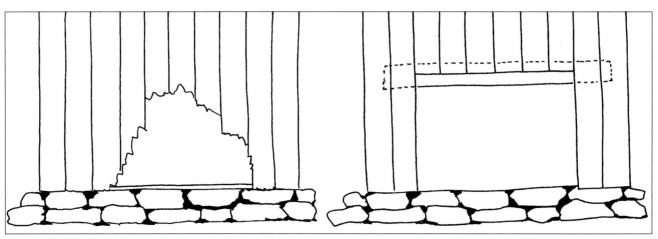

When a section of wall has rotted, the bad sections can be cut out and a nailer attached on the backside so new vertical boarding can be nailed in place.

Straightening Your Barn

Getting Level and Plumb

Leveling your barn should be thought of in relative terms. For the most part, traditional masons were remarkably able to maintain a level foundation for your barn. Even the early English barns set on rubble stones were remarkably flat and level.

Your barn may have settled early in its life and the timbers may have bent to conform. Leveling the frame must account for this bending habit. Timber structures are generally quite elastic, and they try to maintain their original shape despite dramatic climatic influences.

You may not bring your frame back entirely to a level position. It is more important to provide structural stability to your barn than it is to get it perfectly level. This is especially true if the barn has been altered over time when it had already become somewhat misshapen. There is a balance to be met here. You and your contractor must judge the advantage of a level surface with the changes it can introduce into the frame.

Many barns rack, twist, or lean depending on the structural failures in the foundation and frame. Years of weather with high winds and large snowfalls impact how straight your barn remains. Alterations to the frame, especially the removal of angle braces, permit barns to tilt over time. Baled hay thrown into an old barn designed for loose hay storage also contributes to the slant of many a New England barn.

It is important to determine the structural causes for any lean or twist in your barn. A failed foundation can allow the barn to list towards the failure. The removal of braces may allow for the wind to push the barn due to a reduction in the barn's ability to resist lateral loads.

To straighten the barn, it will be necessary first to bring it close to level. This process, however, can negatively impact the degree of lean of the barn if it is not properly restrained prior to the lift.

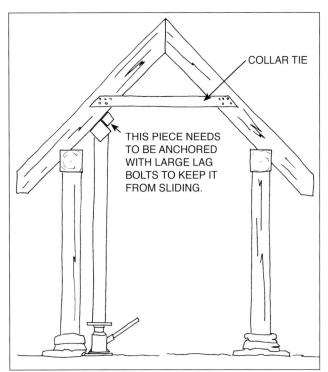

COLLAR TIE

THIS PIECE NEEDS
TO BE ANCHORED
WITH LARGE LAG
BOLTS TO KEEP IT
FROM SLIDING.

Working on the plate may involve jacking up the rafters. Be sure to stabilize the rafters with temporary collar ties to keep them from spreading as you raise the necessary rafters.

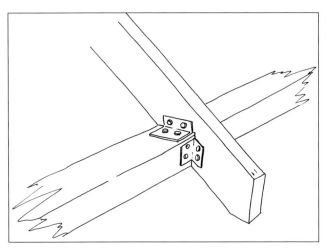

After setting the rafters back down on the new plate, it is a good idea to make them more secure with store-bought or fabricated rafter ties.

Pulling Your Barn Back Together

You may have realized by now that realigning your barn requires an orchestra of lifting, leveling, straightening, and pulling. Generally, if a frame has failed and/or the foundation has settled, joinery in the barn has pulled apart. You may also notice that girts have pulled out of their posts and braces are hanging by only one of their tenons. These are telltale signs that your barn is spreading apart. You must restrain this spread before lifting, leveling, and straightening. Come-a-longs and straps are the most efficient way to do this, but remember that your cross bracing during the stabilization process is also helping to stop the spread of joints.

As you true the frame, it will be necessary to look closely at the joints in the frame. If the roof has exerted pressure on the tie beams and they are damaged, it will be necessary to support the roof system in order to pull the building together.

It is extremely difficult to draw walls back into plumb if the rafters are not supported and lifted at the ridge. This makes for a tall pile of cribbing if you must support the ridge from the ground. Your craftsperson must be versatile and creative when it comes to this portion of the repair process. There are many ways to support the roof system of any barn. Methods vary among craftspeople. This is generally not an area where you can be successful alone.

Cables, straps, and come-a-longs are effective tools in restraining your barn if it is leaning. The advantage of come-a-longs and straps over cables is that they can be tightened and/or released throughout the lifting process to aid in bringing the barn level and straight.

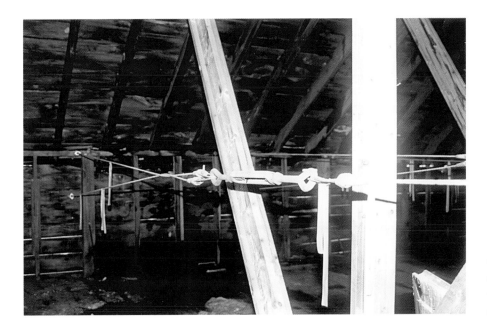

Cables can be used to tie spreading old barns together. They can be cumbersome and get in the way, but these can maintain the structural integrity of the building.

Cables are sometimes used to stabilize a building until it can be properly repaired. They can provide a tension connection between walls to stop spreading. They are rarely an effective tool in a permanent repair, and they are unsightly. It is important to remember that if you repair the timber frame properly, there is no need for cables to restrain the building.

Threaded rods may be used as an alternative to cables. These are also extended through the wall plates and through wooden blocks placed under the eaves and are anchored on the exterior with nuts and washers. Threaded rods can be placed alongside or on top of existing tie beams, where they may be less noticeable and obtrusive than cables. Rods may either be anchored to a vertical post in the center of the barn or extended through the entire width of the structure. Tension is applied by tightening the nut on either end.

Roofs

Maintaining the roof of an old barn is the key to preserving the entire structure. When a roof begins to leak, moisture penetrates boards and framing, and they inevitably decay. A white mass or fungus in a spreading pattern on the face of rafters or timbers indicates deterioration caused by leaks in roof or siding. Large timbers are sometimes rotted

Wood shingles were often the original roofing material used on old barns. Wood shingle roofs are very expensive and when deteriorated are often replaced with other materials. When wood shingles are used, strapping needs to be put down first to allow breathing space.

When there is a bad area of wood shingle roofing, remove the rotten shingles. A special tool may be required to pull out the nails from the last row that is tucked under the existing shingles. Replace any roof boards and furring strips underneath that have deteriorated and replace shingles, trying to minimize the number of exposed nails.

on the inside with no damage evident on the outside. Such decay may penetrate down through a structure, causing supports to give way and weaken the structural integrity of the barn. Quick roof repairs should be an early priority in stabilizing a barn, but a major roof replacement may be one of the last things, because a stiff roof structure may hinder jacking and leveling.

Though not an original roof covering, the metal roofing that was common during the twentieth century has saved many older barns. Sheet metal roofing has a long life and readily sheds snow, alleviating excessive stresses in the structure.

Many old barns were built with an east-west orientation to take advantage of the south sun along one side. This sometimes causes a problem. The ridge may act like a snow fence, dumping blowing snow from the north side onto the south slope of the roof. The unbalanced loading can cause a collapse if the frame is weakened and the snow isn't removed. Asphalt shingle or slate roofs need extra support to carry the additional loads.

Damaged sections of roofing should be replaced quickly to prevent further water infiltration. If most of the roof is in good condition, small sections can be repaired as follows (Wooley 1943, 9–10):

Wood or Asphalt Shingles

Causes of Failure
- Age.
- Wind storms.
- Improper placement or nailing.
- Unsound roof deck.
- Multiple layers of shingles.
- Poor quality shingles.

Steps in Repairing

Wood Shingles

- Remove all old shingles.
- Re-nail roof boards with galvanized nails and replace damaged shingle laths with new furring strips to match the existing or resurface with 4' by 8' sheets of exterior-grade plywood. (Note it is difficult to jack a building after plywood has been applied, so do things in the proper order.) On plywood roof decks, use strapping or a breathing mat, since wood shingle roofs need air circulation under the shingles.
- Pull or drive in all nails.
- Re-shingle using stainless, ring-shank nails.

Asphalt Shingles

- Remove old asphalt shingles.
- Re-nail roof boards and replace damaged places and/or re-surface with 4' x 8' sheet material, which gives a smoother nailing surface (see plywood caution above).
- Apply asphalt shingles using galvanized roofing nails of adequate size (architectural shingles are preferred over tab shingles).

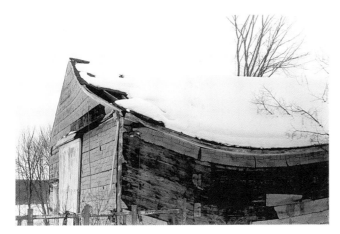

A previous owner let a small section of this roof go unrepaired. Gradually moisture penetrated the roof boards and support members, causing the structure to give way, making it difficult for the present owner to preserve the barn. It is important to repair the little things as they occur.

Metal Roofs

Causes of Failure

- Age.
- Rust.
- Loose fasteners.
- Movement of building.

Steps in Repairing

- Pull all loose nails.
- Re-attach all loose sheets with rubber-gasketed roofing screws
- Fasten between existing nails with gasketed metal screws.
- Use a steel brush to remove loose rust.
- Paint with metallic zinc paint or mobile home roof coating.
- Ground the metal roof to prevent electrical hazards.

New Metal Roofs

- Preferably remove all the old roofing shingles.
- Attach nailing strips horizontally, two feet on center on an old board roof to create a good nailing surface and allow for air circulation.
- Attach the metal roof with gasketed metal screws or hidden attachments according to the manufacturer's recommendations.

Building Maintenance

Proper maintenance of a barn is important in avoiding the need for major repairs and in order to protect the owner's investment, especially after renovating the building. Sometimes taking just a few simple steps each year can prevent major degradation of the structure. We suggest that barn owners carry out a visual check of the barn each year after income taxes are due in April. This is an easy date to remember and, more importantly, falls after the winter season, which can cause major changes in a building through frost heaving, snow loading, water erosion, and other events.

Here are a few maintenance procedures to follow:

- Attend to the small changes that are apparent in the spring. Replace stones that have fallen out of the foundation, dig out water drainage ditches that are misdirected or filled with debris, re-nail loose boards, and make minor repairs.

- Keep grass, trees, and shrubs trimmed away from the building so that moisture is not held against the barn's siding, causing deterioration of the boards and the supporting frame. Placing crushed stone in trenches around the perimeter of the building helps prevent splash back against the barn's siding. Applying a water-repellant wood preservative to the lower three to four feet of the side wall boards can also slow decay.

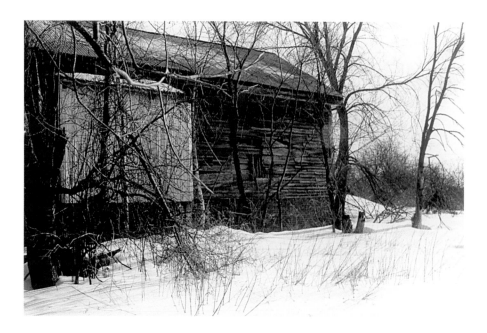

Trees and brush growing beside a barn can cause physical abrasion to the sides and roof of the building. The roots can penetrate the foundation and cause it to cave in. Removing all vegetation around a barn is a basic step for preserving the wood components and keeping things dry.

Keeping floors clear of chaff and debris can help avoid moisture build-up and prevent deterioration of floor boards.

- Patch small problems as they occur. Don't wait until there is enough money to fix an entire roof, wall, or foundation. A metal patch on a roof or a piece of plywood on a side wall may not be attractive, but it's better than letting the elements deteriorate the area further.

- Maintain adequate ventilation. Remove or open windows in the attic and cellar in the summertime to let air circulate and to prevent the build-up of moisture. Installing permanent louvers or vents can ensure both adequate ventilation and protection from the elements.

- Keep debris, such as old hay, chaff, and leaves, cleaned off the floors so that there's no moisture build-up or habitat for insects.

- Install hardware cloth or screening over openings to prevent birds from entering and creating a mess with their droppings.

- Don't remove braces that may be in the way, since braces are critical to the support and rigidity of the frame.

- Check cellar areas and make sure that soil or debris aren't in contact with the bases of support posts. These posts are often set on rock footings, and the soil level should be six to ten inches below the top of the rock base to prevent degradation of the post through moisture from the earth.

- Make sure that existing or unintentional uses aren't detrimental to the barn. Detrimental uses might include manure packs in animal pens, gas and oil leaks from vehicles, storage of leaking liquid containers, and other environmental hazards.

Screened windows or permanent louvers can allow the movement of fresh air through the building and prevent moisture accumulation.

Lean-tos that have a different roof slope than the adjoining buildings can collect snow. The snow can slide from the upper roof to the lower one causing a heavy load and possible structure failure. Lean-to roofs need to be shoveled off occasionally during the winter to prevent problems.

- Don't add lean-tos that may create snow loading problems or cause rainwater to leak into an area of the original structure.

- Routinely check cables, tie rods, and other devices that have been added to support and strengthen the building and plan on replacing them with a permanent fix.

Disassembling and Reassembling a Barn

It is best to preserve a barn on its original site. Unfortunately, changing land uses or major construction may necessitate the removal and relocation of some barns in order to preserve them. Efforts should be made to find a home for a displaced barn, and to reassemble the building on the new site, in a state as close as possible to that of the original. If a barn is in such poor condition that it can't be saved, it is advised to at least save the better pieces of timber and lumber. Someone preserving another old barn may be able to use these materials to replace rotten boards and beams.

When disassembling a barn, start with the roof and then progress downward to the base. This barn was very visible on Route 4 in Chichester, but was moved to a new home in Maine.

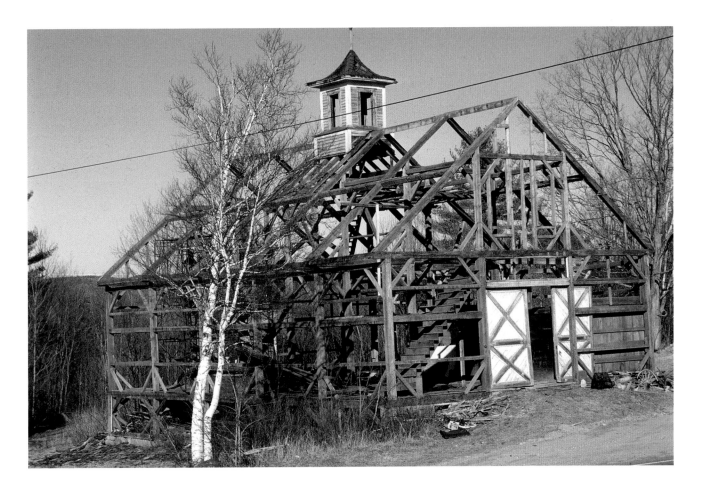

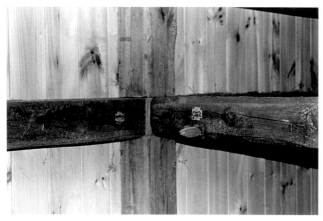

A system of fastening metal tags with numbers onto each structural member can be used to designate the location of pieces on a reassembly plan.

Taking the Barn Down

Dismantling a barn and moving it to a new site is a job for experts. Working among the old timbers is dangerous. Considerable skill is required to disassemble a frame so that the joints are undamaged, and the parts are clearly labeled for reassembly. If original scribe rule "marriage marks" aren't visible after the sheathing has been removed, it becomes necessary to devise a system of labeling joints for reassembly, since each joint in such a frame is custom-made (Vara 1985, 60).

Taking down a barn is a lot of work, and it is dangerous. Follow the safety precautions listed

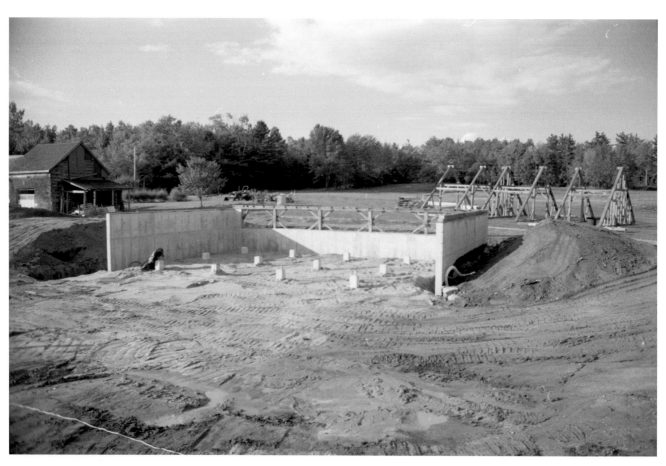

Reassembly of Chichester, New Hampshire barn in Auburn, Maine. An important first step in reassembling a barn is to build a good foundation, and it may need to be other than the original rock wall type used in the early barns. (Photograph by Scott Gardner.)

earlier for renovations. Rope off a perimeter around the barn to keep people away. Wind gusts can grab materials and hurl them for surprising distances.

After a barn has been disassembled, assess dangers that may be associated with the foundation left behind. Fill cellars and wells with soil. Stabilize the foundation stones of open-front cellars so that no loose pieces can fall on someone. If made secure, such walls can be left intact as the backdrop for a flower garden. A stabilized foundation may also be used as the base for a new building in the future.

Reassembling a Barn

The first step in reassembling a barn is to establish a good foundation. If the barn is being placed on an old foundation, make sure that the stones or concrete are secure and that the top walls are level so that the barn's sills will have full support. Then set the sills in place and install the central carrying timbers of the first floor so that floor joists can be inserted. Follow your plan, or the beam labeling system, to be sure that members are returned to their proper places.

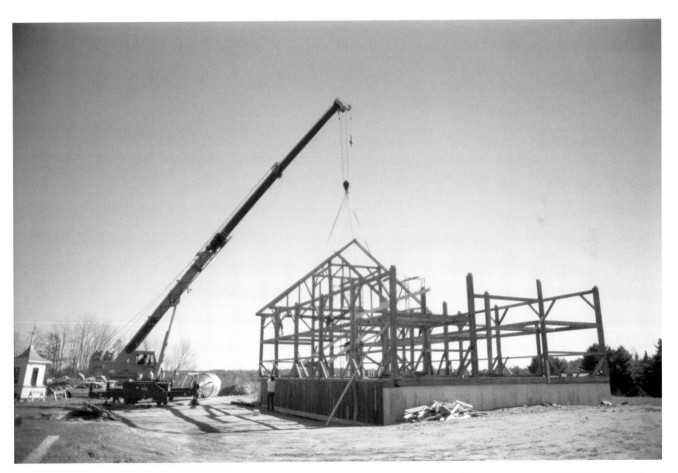

Although early style barns were assembled in bents on the ground and raised by groups of men in a barn raising, today's builders may use cranes and hoists to raise large sections into place. (Photograph by Scott Gardner.)

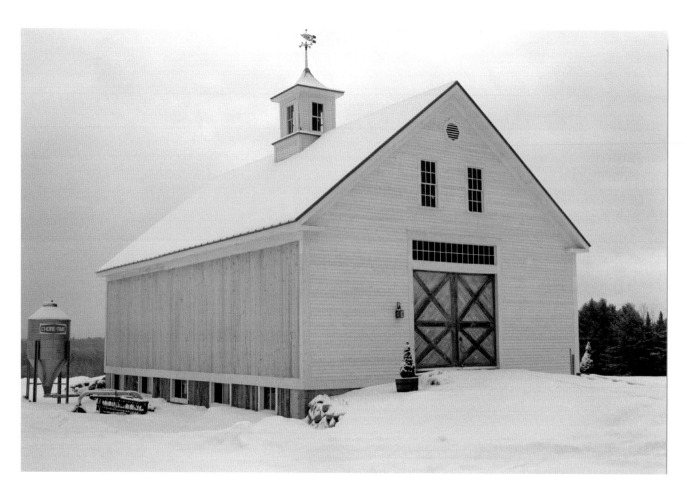

There was a good ending to the Chichester barn story. Although it left New Hampshire, it was beautifully reconstructed on the 1797 Farm in Auburn, Maine. It replaced a long-gone barn on an old farmstead and is now being used to house a sheep dairy. (Photograph by Scott Gardner.)

In a post-and-beam barn, framing units may be reassembled on the ground and then tilted into place. Each section is called a "bent." Post-and-beam barns are erected by tipping one bent upright at a time and then connecting adjacent bents with horizontal members called girts or wall plates. Wooden pegs, called "treenails" or "trunnels," are then driven into holes in the mortise-and-tenon joints to lock them together.

Balloon-framed barns are erected by lifting the entire side wall frame into place at one time and then temporarily bracing the sides in an upright position until a second story or the roof trusses are in place. Use as many helpers as needed to accomplish the raising, along with ropes and poles to push things into place and brace them. Once the shell is up, the wall and roof sheathing boards can be nailed on.

Decide whether the roofing will be authentic or utilitarian. Use either salvaged exterior wall sheathing or materials consistent with the era of the barn. Interior hay mows, stairs, cupola ladders, etc., may need added guard rails for safety.

Authors' Notes

We hope this publication gives the reader an appreciation for old barns. Barns are tangible evidence of our rural past and of the evolution and history of agriculture in New Hampshire. Barns dot the state's landscape and add to the scenic beauty, rural character, and atmosphere that make New Hampshire a very special place.

Maintaining old barns will keep these buildings visibly attractive and structurally sound. Ideally, most of these barns will be used for productive enterprises—whether agricultural or other uses—that return at least some economic gain yet maintain original design features and the integrity of the structures. There have been many changes in agricultural methods, but many of these structures can be re-adapted to be productive in today's agricultural systems. Although some repair work may not be an authentic restoration, at least further deterioration is prevented.

Many of these repairs are not for amateurs. This publication serves as a guide to assess needed repairs and assist with minor repairs. Major jacking and reconstruction should be left to the experts.

Only if people gain an appreciation for old barns will they be preserved and maintain their rightful place in New Hampshire's landscape. Although barn preservation is often hampered by concerns about property taxes and fire insurance, progress has been made in changing statewide policy. Don't hesitate to ask town officials about potential positive impacts of barn projects in your community and demonstrate to them the public good that can come from saving, preserving, and re-using old barns.

For help with current information on barn preservation efforts and names of barn repair specialists contact:

New Hampshire Division of Historical Resources
19 Pillsbury Street
Concord, NH 03301
Tel: 603-271-3483
Email: preservation@dncr.nh.gov
Website: www.nh.gov/nhdhr

New Hampshire Preservation Alliance
7 Eagle Square | P.O. Box 268
Concord, NH 03302-0268
Tel: 603-224-2281
Email: admin@nhpreservation.org
Website: www.nhpreservation.org

Appendix

Tax Incentive Mechanisms to Help Save Old Barns

Part of the challenge in saving old barns is that they are no longer used for their original function, so there is little economic incentive for maintaining them. When barns were part of someone's livelihood and used for housing cattle and storing hay and grains, regular repairs were part of the normal cost of business in maintaining the agriculture infrastructure on the farmstead. Unfortunately, today these massive old structures with internal posts, low ceilings, and narrow doors don't lend themselves to mechanized, modern agriculture. Often it is more efficient to build a new pole barn which can accommodate tractors or invest in the greenhouses and high tunnels that characterize many new agricultural enterprises. There are also pressures from development which cause these structures to disappear from the landscape.

The present property tax structure in the state has almost created an obstacle for preserving old barns, since fixing up a barn structure which doesn't have an economic return can result in a higher tax bill. Seeing this dilemma, the New Hampshire Historic Agricultural Structures Advisory Committee ("Barn Committee") garnered support from barn enthusiasts and legislators around the state in 2002, resulting in the passage of NH RSA 79-D. This created a mechanism to encourage preservation of old New Hampshire barns and other historic agricultural buildings with an easement.

The program was modeled after New Hampshire's discretionary easement program (RSA 79-C), which authorizes local governments to grant property tax relief to encourage the preservation of open land. On or before April 15 of the new tax year, any owner of an historic barn or other farm building over seventy-five years old may seek relief by applying to their local governing body (board of selectmen or city government) to grant a discretionary easement to the municipality and agreeing to maintain the structure in keeping with its historic integrity and character during the term of the easement.

The local officials have sixty days to act on an application. A public hearing is required, and if the municipality determines, in exercising its discretion, that the proposed preservation of the structure is consistent with the purpose of the law, it may acquire an easement on the structure for a minimum of ten years and grant tax relief within a range of a 25 to 75% reduction of the full-assessed value. Maintaining and repairing the

building will not result in an increased value for property tax purposes. As of this writing, there are ninety-six municipalities participating in this program and about 570 structures enrolled. For information about NH RSA 79-D, the Discretionary Preservation Easement (known as the "barn easement"), and historic barn assessment grant opportunities, see the "Resources" section on the NH Preservation Alliance website (www.nhpreservation.org).

Owners of historic barns that need to be repaired for either agricultural purposes or some other commercial purpose may also be able to take advantage of the Federal Historic Preservation Tax Incentives Program, which encourages private sector investment in the rehabilitation and re-use of historic buildings. Property owners across the country and in New Hampshire have already used this tax incentive to rehabilitate a wide range of historic barns. The amount of credit under the program equals 20% of the qualifying costs of the project, which must also preserve the barn's important historical and architectural characteristics in keeping with the Secretary of the Interior's Standards for Rehabilitation.

The program is administered by State Historic Preservation Offices, the National Park Service, and the Internal Revenue Service. In New Hampshire, the Division of Historical Resources in Concord is the State Historic Preservation Office.

Mineral Spring House (today Westwynde) in Moultonborough, a seasonal boarding house that catered to tourists, circa 1900. (Photograph courtesy of Cristina Ashjian.)

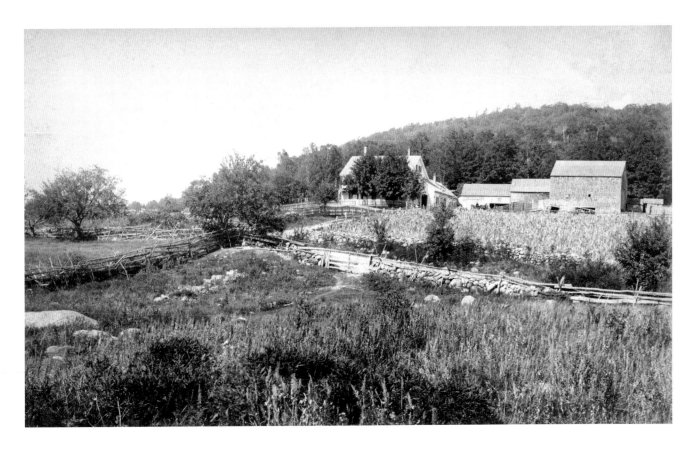

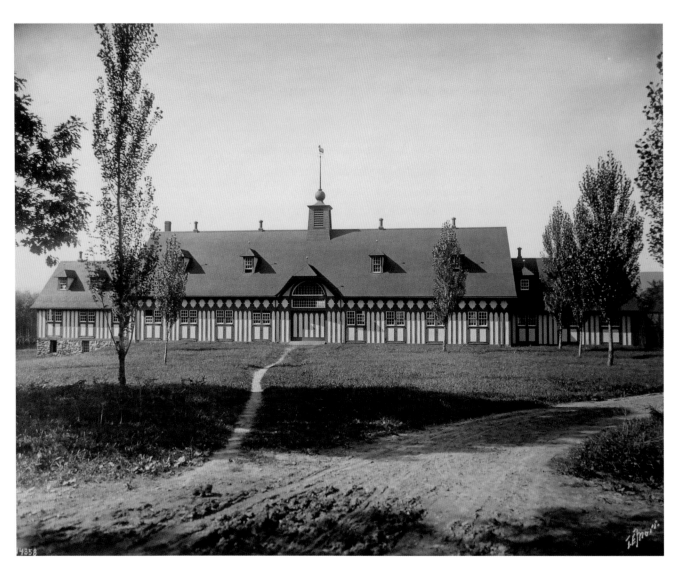

*The Kona Farm estate sheep
barn, Moultonborough Neck,
circa 1907. Designed by Boston
architect Harry J. Carlson, only
far left section of the barn remains.
(Photograph by Thomas E. Marr,
courtesy of Cristina Ashjian.)*

Bibliography

Arnett, Jan Corey. *American Barns*. New York: Bloomsbury Publishing, 2013.

Atwell, Debby. *Barn*. Boston: Houghton Mifflin Company, 1981.

Aurer, Michael J. *Preservation Briefs 20: The Preservation of Historic Barns*. U.S. Department of the Interior, National Park Service, 1994.

A Vermont Heritage: Agricultural Buildings and Landscapes (Video). Montpelier, VT: Vermont Division for Historic Preservation, n.d.

Bailey, John M. *The Book of Ensilage*. New York, NY: Orange Judd Company, 1881.

Barn Again! Celebrating the Restoration of Historic Farm Buildings (Video). Lincoln, NE: Nebraska ETA Network/University of Nebraska, Lincoln, 1991.

"Division 6 Special Report: Barns & Barn Specialties." *Traditional Building* 12, no. 2 (March/April 1999): 70–89.

Engler, Nick. *Renovating Barns, Sheds, and Outbuildings*. Pownal, Vermont: Storey Books, 2001.

Falk, Cynthia G. *Barns of New York*. Ithaca, NY: Cornell University Press, 2012.

Fink, Daniel. *Barns of Genesee County, 1790–1915*. Geneseo, NY: James Brunner Publisher, 1987.

Garvin, James L. *A Building History of Northern New England*. Hanover, NH: University Press of New England, 2001.

Griswold, James W. *A Guide to Medieval English Tithe Barns*. Portsmouth, NH: Peter E. Randall Publisher, 1999.

Harris, Bill. *Barns of America*. New York, NY: Crescent Books, 1991.

Hengen, Elizabeth Durfee, and Kevin De Grenier. *Jaffrey Agricultural Survey: An Overview*. Jaffrey, NH: Jaffery Historic District Commission, 1996.

Howe, Nicholas S. *Barns*. New York: Metro Books, Friedman/Fairfax Publishers, 1996.

Hubka, Thomas C. "The Connected Farm Buildings of Northern New England." *Historical New Hampshire* 32, no. 3 (Fall 1977): 87–115.

Hubka, Thomas C. *Big House, Little House, Back House, Barn: The Connected Farm Buildings of New England.* Hanover, NH: University Press of New England, 1984.

Iowa Barn Foundation. *Iowa Barn Foundation Magazine.* Nevada, IA. Semi-annual.

Johnson, Curtis B. and Thomas D. Visser. *Taking Care of Your Old Barn: Ten Tips for Preserving and Reusing Vermont's Historic Agricultural Structures.* Vermont: Vermont Division for Historic Preservation and Vermont Housing and Conservation Board, 2001.

Johnson, Dexter W. *Using Old Farm Buildings.* Fargo, ND: North Dakota State University, 1988.

Klamkin, Charles. *Barns: Their History, Preservation and Restoration.* New York, NY: Bonanza Books, 1979.

Larkin, David, Elric Endersby, and Alexander Greenwood. *Barn Preservation and Adaptation.* New York: Universe Publishing, 2003.

Leffingwell, Randy. *The American Barn.* St. Paul, MN: Motorbooks International, 1991.

Noble, Allen George, Richard K. Cleek, and M. Margaret Geib. *The Old Barn Book: A Field Guide to North American Barns and Other Farm Structures.* New Jersey: Rutgers University Press, 1995.

Penacook Historical Society. *A House, A Barn, a Community* (DVD). Concord, NH: Accompany, 2006.

Perkins, Don. *The Barns of Maine.* Charleston, SC: The History Press, 2012.

Rawson, Richard. *Old Barns Plans.* New York, NY: The Main Street Press, 1979.

Sloan, Eric. *An Age of Barns.* New York: Funk & Wagnalls, 1967.

Sommer, Robin Langley. *The Old Barn Book: A Pictorial Tribute to North America's Vanishing Rural Heritage.* Rowayton, CT: Prospero Books/ Chapters, Inc, 1997.

Starr, Markham. *Barns of Connecticut.* Middletown, CT: Wesleyan University Press, 2013.

Triumpho, Richard. *Round Barns of New York.* Syracuse, NY: Syracuse University Press, 2004.

Valuing New Hampshire Agriculture (Video). Durham, NH: University of New Hampshire Cooperative Extension, n.d.

Vara, Jon. "Giving Old Barns New Life." *Country Journal*, June 1985, pp 48–60.

Visser, Thomas Durant. *Field Guide to New England Barns and Farm Buildings.* Hanover, NH: University Press of New England, 1997.

Weller, John. *The History of the Farmstead*. Norfolk, Great Britain: Faber and Faber Limited, 1982.

Wooley, J. C. *Farm Building Repair*. Columbia, Missouri: University of Missouri College of Agriculture Experiment Station, Circular 279, 1943.

Wysocky, Ken. *This Old Barn*. Iowa: Reiman Publications, 1997.

Other Resources

Iowa Barn Foundation
c/o Community Bank
P.O. Box 436
Nevada IA 50201
Tel.: 515-255-5213
Web site: www.iowabarnfoundation.org

National Barn Alliance
Ohio State University
Department of Food, Agricultural and Biological Engineering
590 Woody Hayes Drive
Columbus OH 43210-1057
Tel.:614-292-6131
Fax: 614-292-9448
Web site: http://fabe.osu.edu/extension-outreach/barnagain

Barn Photography
Lowell Fewster
400 Seabury Drive, Apt. 5200
Bloomfield CT 06002
Email: LFewster2@gmail.com
Web site: lowellfewster.com

John C. Porter. (Photograph by
Sue Porter.)

Francis E. Gilman.

About the Authors

The authors of this book are John C. Porter, Extension Professor/Specialist, Emeritus with UNH Cooperative Extension, and Francis E. Gilman, Agricultural Engineer, Emeritus, UNH Cooperative Extension; with significant contributions by photographer Lowell H. Fewster, and by barn expert Arron Sturgis.

John Porter grew up on a dairy farm in Lebanon, New Hampshire. After going to college at the University of New Hampshire and Cornell University, he worked for a year in central New York before returning to his home state, where he was a dairy specialist for UNH Cooperative Extension from 1974 until his retirement in 2006. In that position, he visited farms around the state and advised them on herd health, nutrition, and facilities, and conducted educational meetings and conferences. He spent his career working in dairy management and helping farmers design and renovate modern dairy facilities. He has applied these concepts, along with his practical experience from growing up on a New Hampshire dairy farm, to the art and science of preserving old barns. John is Extension Professor/Specialist Emeritus, still works part-time, and has his own consulting company.

Francis Gilman was a native of Lovell, Maine, and after serving his country in World War II and finishing college at the University of Maine, he started out as an engineer for utility companies, specializing in electrical applications for farms. He came to the University of New Hampshire as an Extension Agricultural Engineer in 1969. Francis served for over twenty years as an Agricultural Engineer for UNH Cooperative Extension, helping farmers around the state evaluate and improve their facilities. He was well known throughout the Northeast for his knowledge and practical approach to rehabilitating structures. He retired in 1990 and in his emeritus status was willing to continue to give of his time. He assisted in writing and providing technical details for both editions of this book. Francis died on July 24, 2018, just a week prior to his ninety-second birthday and before the completion of this edition.

John and Francis had a long-time relationship of working together, starting when John was a student at UNH and had Francis as a guest lecturer in dairy management classes. Later they became co-workers when John joined UNH Cooperative Extension. They spent many miles together doing farm visits around New Hampshire, and Francis

Lowell H. Fewster.

was a mentor to John for passing on some of the basics of agricultural engineering. After Francis retired, John took over his files and continued to work with farmers on facilities and farmstead planning.

A third author has been added to this edition, photographer Lowell Fewster of Bloomfield, Connecticut. Lowell, who often accompanies John Porter on summer tours of New Hampshire barns, supplied many new color photographs, including the front cover images and others as noted in the section showing examples of preserved barns. John and Lowell connected in about 2004 when John did a barn talk in Litchfield, Connecticut. Later Lowell invited him down to speak to his historical society in Windsor, Connecticut. A friendship started which led Lowell to come to New Hampshire for one or two days each summer to join John on a tour of New Hampshire barns, and Lowell would photograph dozens of barns. He used these photos to create framed pictures for exhibits and make calendars. When it came time to put together the second edition of the book, it became obvious that Lowell had quite a collection of images which could add to the book.

Growing up in a Kodak family in Rochester, New York, Lowell had a camera at an early age and photographed his father's barn as one of his first subjects. Professionally as a minister, he served as a pastor, campus minister, seminary administrator and regional church leader in Wisconsin, upstate New York, and Connecticut. In his retirement, he has focused on photography. With his love for barns, they became his primary subject, and he has developed a skill for capturing the magnificence and detail of these structures.

Two barn experts contributed a great deal to this second edition. Both have years of experience preserving old barns and other historic structures and educating property owners about preservation strategies and benefits. Arron Sturgis, owner of Preservation Timber Framing, Inc., in Berwick, Maine, added substantial new material to the preservation chapter on assessing old barns. Stephen Bedard, of Bedard Preservation & Restoration, LLC, in Gilmanton, New Hampshire, a member of the New Hampshire Historic Agricultural Structures Advisory Committee, provided a thorough edit of the sections on barn assessment and preservation.

The second edition of *Preserving Old Barns* builds on the original text, which was written to provide a practical handbook for barn owners. Hopefully you'll find these added enhancements and additional information helpful.